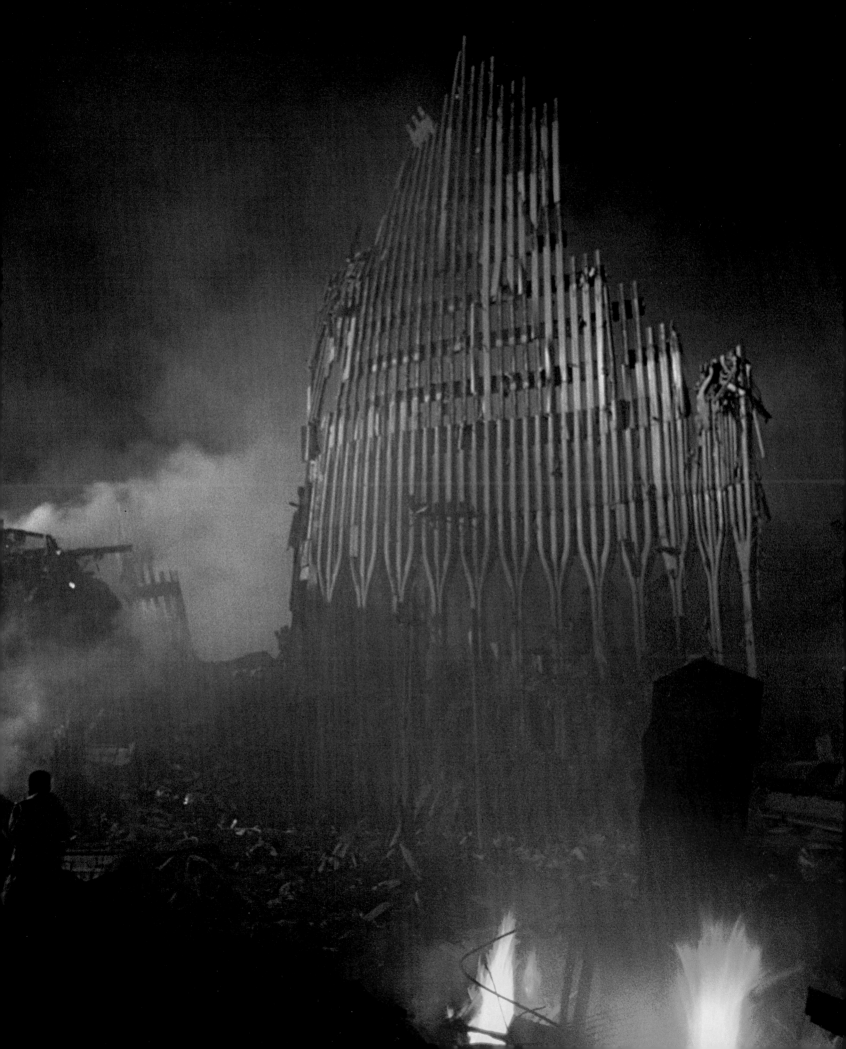

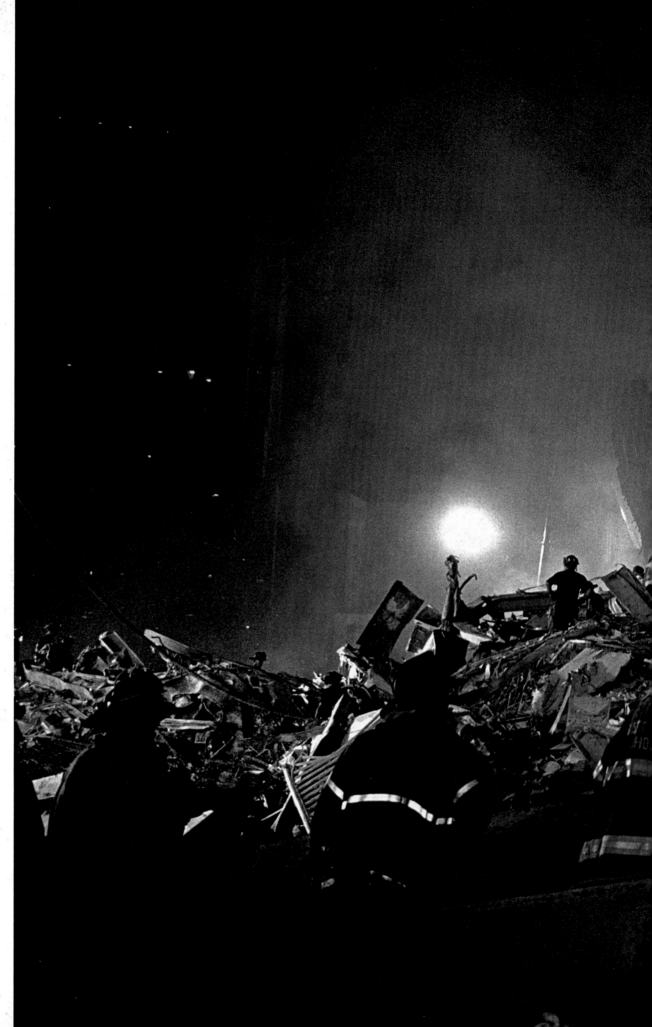

Cover:
SALANG PASS, AFGHANISTAN. NOVEMBER 9, 2001
Northern Alliance soldiers face the onset of winter at the mountainous front line in the Hindu Kush mountains. The Salang Pass is about sixty miles north of Kabul, less than a mile to the Taliban forces.

Previous page:
NEW YORK, NEW YORK. SEPTEMBER 12, 2001
Flames from beneath the rubble of the demolished Twin Towers at Ground Zero.

NEW YORK, NEW YORK. SEPTEMBER 13, 2001
The rescue effort continues into the night at Ground Zero.

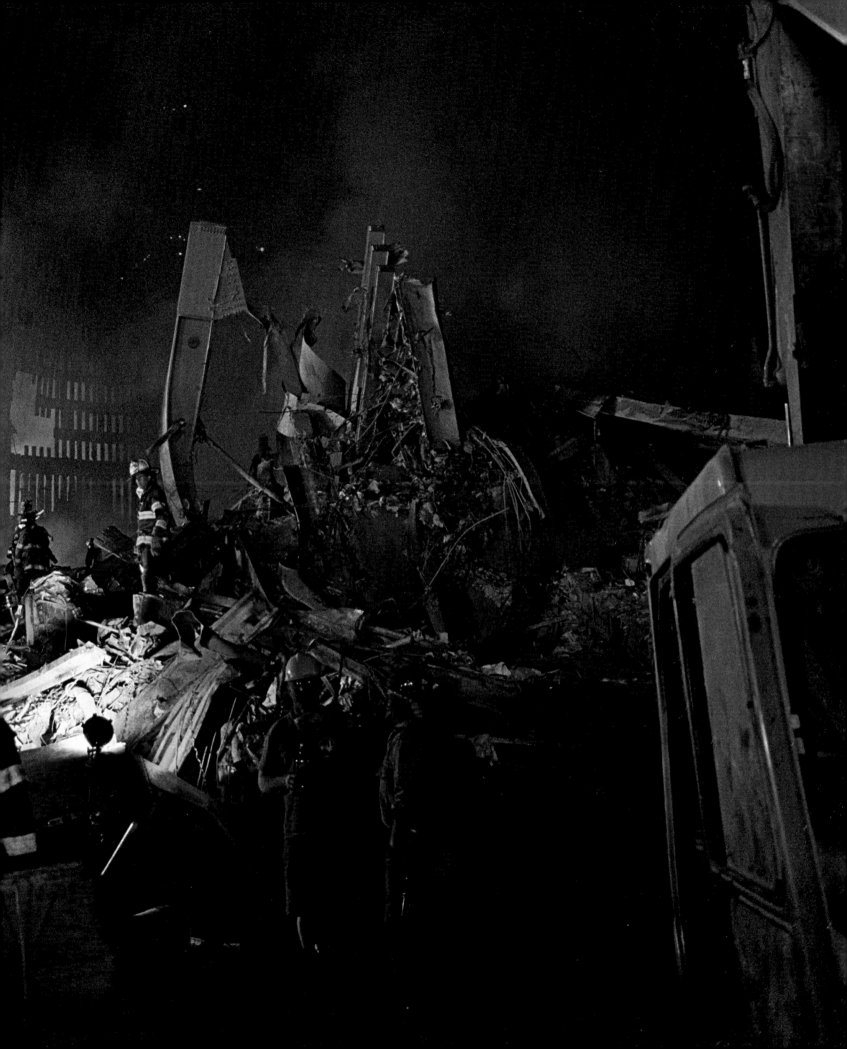

**NEW YORK, NEW YORK.
SEPTEMBER 14, 2001**
Hope for survivors
diminishes as the emer-
gency brigade works
around the clock in
their rescue effort.

Following page:
**NEW YORK, NEW YORK.
SEPTEMBER 14, 2001**
Fire Department offi-
cials watch from the
Atrium, which had
become one of their on-
site places of operation
adjacent to the fallen
towers.

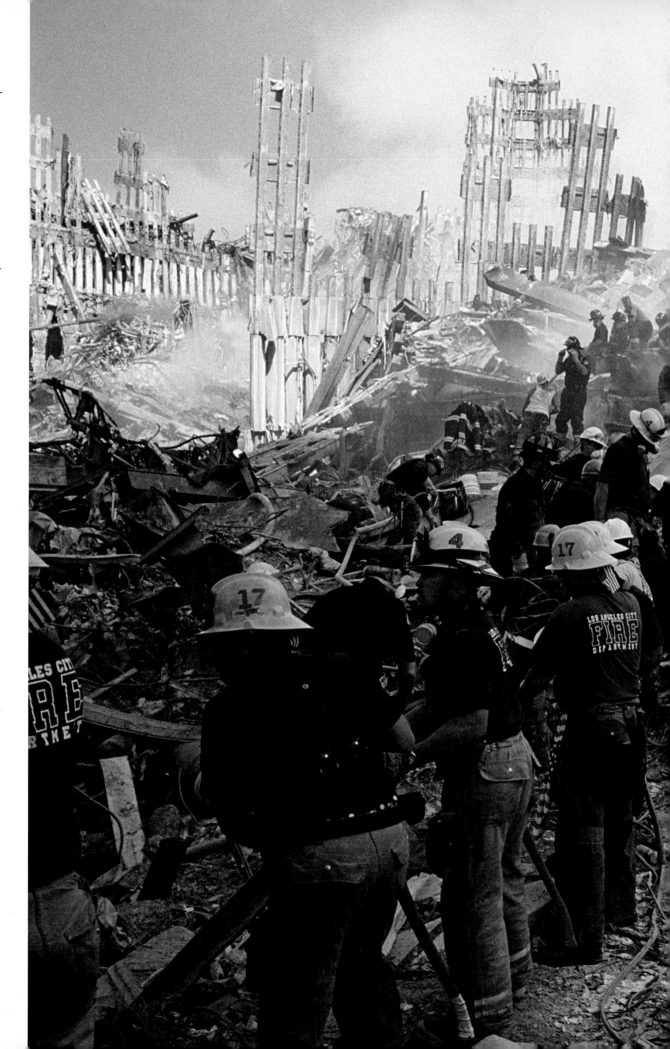

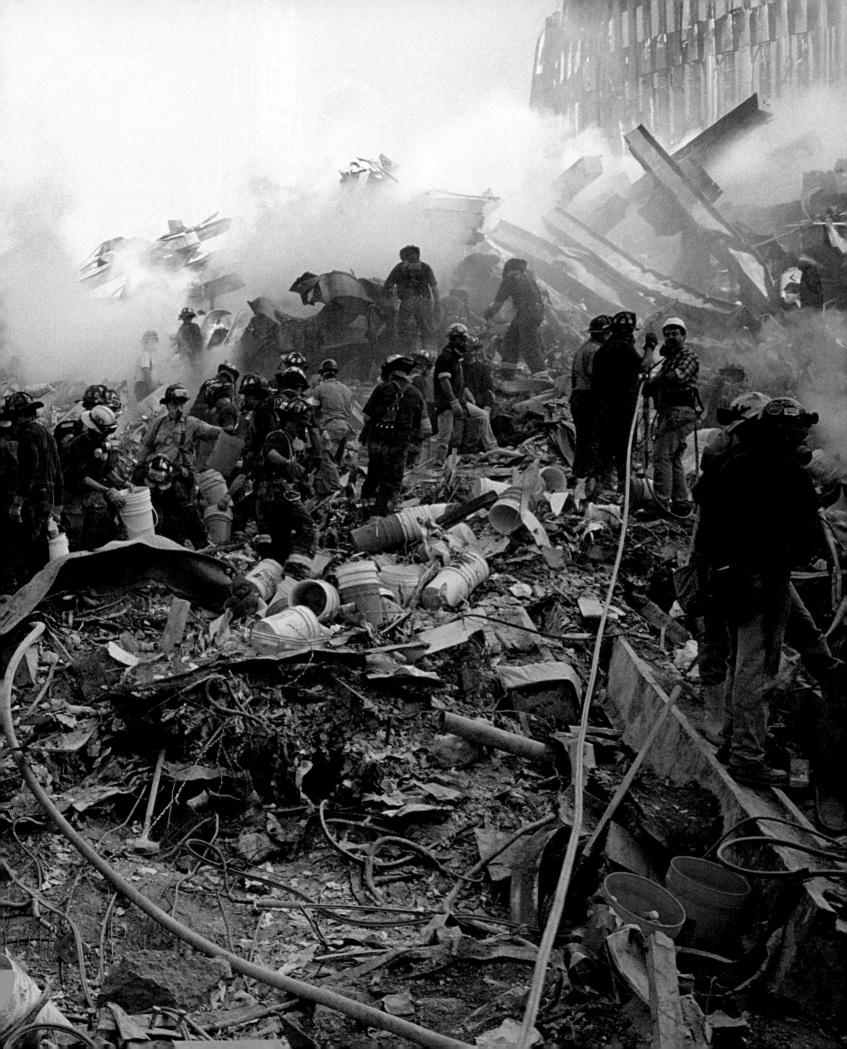

HISTORIES ARE MIRRORS
THE PATH OF CONFLICT THROUGH AFGHANISTAN AND IRAQ

Photographs by Tyler Hicks
Essays by John F. Burns and Ian Fisher

Umbrage Editions

TARMIA, IRAQ. JUNE 29, 2003

5:00 am. One of a series of raids, from Balad to Tikrit, was carried out in the early hours of the morning by the American Fourth Infantry Division, Third Brigade battalion armored unit on a compound of homes about thirty kilometers north of Baghdad. Fourteen Iraqis were detained at the scene, with three taken into custody for further questioning. The Americans swept into the compound, looking for Col. Adeed, formerly with Iraqi intelligence and believed to have a part in organizing attacks against Americans in Iraq. He was not found.

ESSAY BY JOHN F. BURNS

The greatest war photographers are born, not made. Good apprenticeships, strong editors, the best equipment, generous contracts underwriting foreign travel, fearlessness tempered with a well-developed instinct for survival—are all part of the armory. But their function, at best, is to shape and enable an inherent talent, an ability that is, in the end, innate.

As in all creative endeavors, those less gifted can compensate for a lack of a divine spark with application, and over the long term outperform those with an abundance of natural talent but little

by way of drive. But at the highest level, it is those who harness a relentless quest for excellence to a rare, in-born talent that write their names in the pantheon of their craft. They are the masters; all others, the journeymen of the trade. The gift is something the commonest man can recognize, even if its origins are something he can never fully grasp.

In the case of Tyler Hicks, the most telling acknowledgment of his natural ability came from a critic who had never seen the photographic galleries of London and New York and Paris, a man uninitiated in the accomplishments of Robert Capa or Larry Burrows—or of the subtleties of Canon, Leica, or Nikon—before the world's best war photographers began knocking on his door in Afghanistan back in the 1980s.

Mention Amir Shah in any foreign correspondents' club between London and Tokyo, and his admirers will gather round. Once, he was a taxi driver, a genial but unpolished teenager soliciting rides outside the Inter-Continental Hotel in Kabul, the gloomy hostelry that became, under the Soviet occupation of Afghanistan, the dedicated barracks for the foreign press. Later, with his battered, twenty-five-year-old yellow Toyota Corolla, Amir became driver by appointment—and fixer par excellence—for a generation of journalists who found in him a means of escaping

the smothering embrace of the Soviet-installed government in Kabul, and of its successors a few years on, the Taliban.

With a wealth of talent of his own, Amir is a now reporter for the Associated Press at its bureau in Kabul, his stories and photographs appearing in some of the world's greatest newspapers. But that is a story for another time. What is of concern here is Amir's reaction after he first met Tyler, during the weeks of fighting and bombing that ended with the American-backed troops of the Northern Alliance driving the Taliban out of Kabul in November 2001.

In Amir's lexicon, photographers fall into two categories— "hunter" and "not hunter." Tyler Hicks, he told me when we met again in Kabul after the Taliban's collapse, drawing Tyler's card from a box on his dashboard that held cards from a "Who's Who" of world journalism, was most decidedly a hunter. "Good hunter, big hunter," he said, before pausing a moment to reflect. Then, as if reviewing the matter in his personal court of appeal, he revised his verdict. Tyler was, he pronounced, maybe the top hunter. The phrase came back to me nearly a year later, towards sunset on the evening of October 20, 2002. Tyler and I, re-assigned by *The New York Times* from Afghanistan to Iraq as the focus of President Bush's war on terror moved on, found ourselves caught up in a desperate, surging mass of people in the vast inner courtyard of the prison at Abu Ghraib, twenty miles west of Baghdad.

Yet another year was to pass before Abu Ghraib became a symbol of shame for the American forces in Iraq, the fortress where American soldiers abused and humiliated some of the thousands of Iraqi detainees swept up in the insurgency that followed the American invasion. But on that fateful October day, in the still-searing heat of Saddam Hussein's last autumn in power, we were witnesses to an event that told us more about the terror the Iraqi dictator had inflicted on his country than anything seen in Iraq in years.

At mid-morning, foreign journalists staying at the Al Rashid Hotel in Baghdad were notified over the hotel's public address system to gather at the information ministry. There, we were formed into a chaotic, weaving motorcade, careening at 120 miles an hour westwards out of the city, and finally to the outer gates of Abu Ghraib.

Soon, a huge crowd gathered, tens of thousands of desperate, hopeful Iraqis who had heard the rumor soon confirmed by loudspeakers at the gates: Saddam Hussein had ordered a comprehensive amnesty for all prisoners in Iraq, saving only murderers who had made no financial settlement under Islamic law with their victims' families and "spies" caught working for Israel and the United States.

At Abu Ghraib that autumn afternoon, the crush of thousands of families in hope of finding lost brothers and husbands and sons eventually broke through the gates. Guards fled. In moments, spread out before the reporters and photographers swept into the prison compound with the mob, was a tableau of all Saddam and his government of thugs had striven for a quarter of a century to conceal.

Out of the gulags, with the pallor normally seen in a morgue, came thousands of astonished, terrified men and boys. Each of them had a story, shouted as they ran and stumbled towards the open gates—stories that, together, made for a grim tapestry of deprivation, torture, and death.

As night approached, the desperation of families unable to find their missing ones grew, and with it their anger and frustration. All but a handful of western journalists had already left, pressed by fears for their safety and the drumbeat of approaching deadlines.

My concern was to find Tyler, lost hours before in the mob, and to make our own way back to Baghdad. Finally, I found him, but only long enough to hear him say that the day's strongest images were still out there somewhere in the gathering gloom. For a moment, I thought him a man incapable of weighing benefit against risk—and then I remembered how, on other assignments, I had seen this same unreasoning persistence yield astonishing results.

And so it was, again, at Abu Ghraib. By staying on when all others had gone, Tyler was there to capture the moments when the inmates of the cellblock, kept imprisoned through the afternoon as other cellblocks emptied, tried to fight their way out past guards with lengths of lead pipe while the mob, outside, smashed holes through the cinderblock walls that would give them a path to freedom.

In that tragic passage, with men dying before him at the moment of their liberation, Tyler made images that stand as a metaphor for man's struggle for freedom. Was it luck that he was there, as some of his competitors suggested later? Or was it that indefinable thing, the instinct to find, and capture, the moment that defines an event? My conclusion, after watching Tyler accomplish similar things again and again, was that it was instinct, coupled with the kind of obsession that so often separates the achievement of excellence from the merely ordinary.

The photographs Tyler took that evening at Abu Ghraib are only a part of the talent displayed within these pages. Readers of *The New York Times* and of the newspaper's website will long have admired his wider body of work, photographs that will go a distance towards defining for future generations what it like was to be there at many of the crucial moments after 9/11 that sent America to war.

Lastly, a more personal postscript. Nobody who has worked with Tyler would accept that an essay about his talent as a photographer could even approximately do him justice if it failed to mention something else that is equally striking. In a profession that is as hard-edged and competitive as they come, Tyler wears his talent, and all else, with an innocence and modesty that is as rare among the high achievers in our business. The most dangerous assignments seem shorter for Tyler's stories, tales of the vicissitudes, miscues, and absurdities of life. There is no war, and certainly no gathering of journalists in these faraway lands, that is not made more bearable by the arrival, ever-smiling, of Tyler Hicks.

—JOHN F. BURNS
 BAGHDAD, IRAQ. SEPTEMBER 2004

ESSAY BY IAN FISHER

In the early autumn of 2003, a French doctor was struggling to explain to me what made the war in Iraq so hard to navigate, so misleading on its surface. The pageantry of the American invasion, with its shock-and-awe fireworks and columns of camouflage and armor, was long over. Baghdad felt more-or-less normal, maybe even stabilizing. Streets stripped of Saddam Hussein's creepy portraits were now clogged with newly-bought cars and trucks hauling goods not allowed in Iraq for thirty-five years. Westerners, like the French doctor or American soldiers, could go almost anywhere safely.

"It all seems fine—then suddenly, boom!" he said.

The defining moment he was describing was the start of what might be called the real war in Iraq. As in Afghanistan, the other American war after 9/11, it was not a war of certainties, of defined fronts and armies facing each other with equal and deadly purpose. Thousands may have died in single days in Gettysburg or the Somme, but there was, for all the horror, something graspable in those places: men in uniforms, sent to fight on behalf of nations or to create nations.

In Iraq, the fighting did not take place on conventional battlefields, but in the arena of everyday life. In Iraq, they were not battles so much (though they did happen, as in Najaf in the late summer of 2004) but single moments in which normalcy

JALALABAD ROAD, AFGHANISTAN. SEPTEMBER, 2002
A shepherd crosses the rural Jalalabad Road, the main artery between Kabul and eastern Afghanistan.

exploded. Cars packed with TNT or artillery shells—even an enormous torpedo at one bombing I covered—blew up at mosques and churches full of worshippers, embassies, the United Nations, police stations where fathers of large extended Arab families lined up to collect their pay. Mortars rained down on schoolchildren. The fighters called themselves resistors, heirs to a tradition of guerrilla warfare against an occupying army. They were apt to compare Iraq to America's last major war, in Vietnam, also a guerrilla conflict. This was true for some fighters there, especially the Shiite militiamen who followed the fiery young cleric Moktada al-Sadr. But others showed a disregard for civilian life that, even many Iraqis said, put them in a different category: terrorists, and nothing more.

On the other side, Americans pilots dropped bombs that for all their precision still killed civilians, both inadvertently and because resistors used citizens as human shields. Drivers died under American fire at checkpoints. The intent was different from those who set off car bombs. Few accuse Americans of deliberately targeting civilians. But the fact remained: this was a messy war fought where ordinary people lived.

So the images, from Iraq especially, were less akin to those from traditional wars, of young men dying in blood-clotted trenches, than to the awful arbitrariness of this new chapter of the terror of militant Islam around the world: of tourists dying in Bali; of commuters with briefcases and cell phones in Spain; of schoolchildren in a gym in Russia. And, at the start of it all, of nearly 3,000 people—of every kind and belief—killed at work at the World Trade Center on September 11, 2001.

In the anguish and anger after the attacks in New York and Washington, America's leaders nurtured hope that this new era of

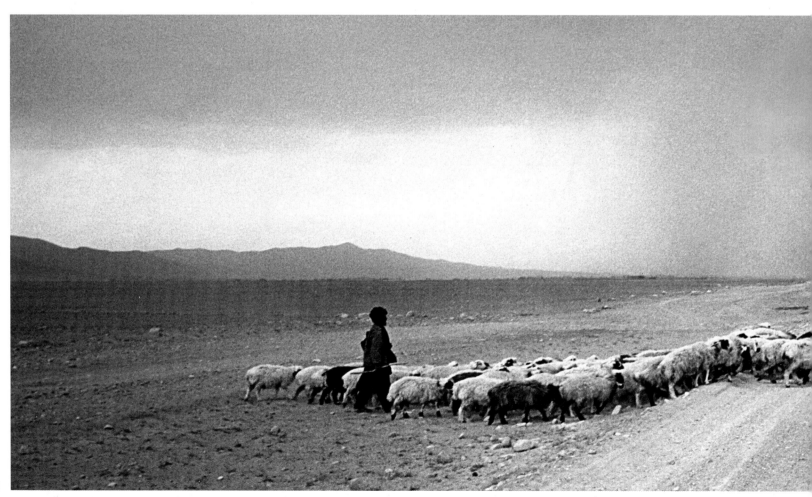

war could be fought, to some degree, conventionally. Just over a month after 9/11, U.S. troops, backed by more allies than they even expected, invaded Afghanistan, aimed at toppling the Taliban regime and destroying Al Qaeda's leadership hiding there. Americans fought aside the Northern Alliance, easily taking every major city. Soon the Taliban was disolved and most Afghanis were elated. They looked forward to the American promises of peace and democracy.

The next year in Iraq, the idea was the same, at least to the American leaders who planned the war. American troops would topple a dictator who posed an immediate threat with weapons of mass destruction and a future threat in any possible alliance with terrorists. As with the fall of the Taliban, American planners intended that the world would become safer with Saddam Hussein overthrown and the first real democracy implanted in the Middle East. Some of America's allies from Afghanistan begged to differ: there was no evidence that Iraq had weapons that were an immediate threat, nor that Saddam was cooperating with Al Qaeda. An invasion of Iraq, they argued, could only make it worse.

In Afghanistan and Iraq, the invasions were successful in many ways, certainly by the military measure of toppling the Taliban and Saddam Hussein. But many critics say the invasions also showed the limits to conventional military power, in places as complicated and isolated as Iraq and Afghanistan and against an enemy like militant Islam, which does not aspire to anything as understandable as a nation. Its goals are murky and apocalyptic. It makes few distinctions between soldiers and innocents.

At the end of the war in Afghanistan, Al Qaeda no longer could operate freely. But nor have U.S. troops completely destroyed it

or captured its leader, Osama bin Laden, to date. Three years later, the Afghani government controls only a portion of the country.

In Iraq, Saddam Hussein is in jail, and for that most Iraqis are genuinely grateful. But the invasion opened the door to a new reality far outside the control of any army: the nation itself is a battlefield, as the three major groups, Shia, Sunni, and Kurd, struggle to protect their interests against an uncertain future. Causes are becoming confused. There are insurgents in Iraq who kill Americans purely as a way to resist occupation. There are others in Iraq, and Afghanistan too, who view the fighting as part of the larger war against America, its presumed ambitions in the Middle East, or simply against Western culture. It is often hard on the ground to separate the two struggles: Some Iraqis and foreign fighters have joined forces. They make for an elusive enemy. Their weapons are kidnappings, ambushes and big bombs that—in an unexpected instant—obliterate whatever is near.

And, as terror attacks around the world show, fighters for militant Islam do not see Iraq and Afghanistan as the only battlefields. A generation ago, American leaders cast the guerrilla conflict in Vietnam as one front in a global war against communism. But, outside of Vietnam, that was mostly a cold war. The war with militant Islam, another ideology, is a hot one right now. After 9/11, our army has been deployed outside our borders at full strength, and it is unclear to me if we are winning. But we are waiting, in some fear, for what comes next.

—IAN FISHER
ROME, ITALY. SEPTEMBER 2004

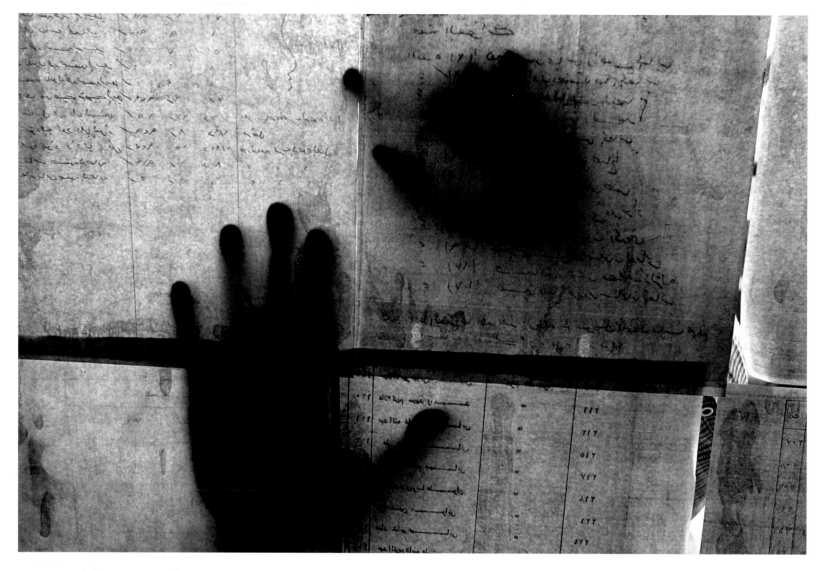

BAGHDAD, IRAQ. APRIL 18, 2003
The families of tens of thousands of Shiite Muslims, most of whom disappeared following the 1991 uprising because of their participation in opposition political groups, now had the opportunity to identify missing relatives and bring closure to their fate. Many others had vanished in those twenty years, such as the names posted for the first time on a bus window in Baghdad.

FOREWORD BY TYLER HICKS

Before 9/11, I had never photographed an American war of the magnitude we've seen in Afghanistan and Iraq. The conflicts I had covered were other people's wars, far from home, in unfamiliar cultures and countries. Although it was the United States that bombed the Milosevic regime, where we photographed the peacekeeping mission that followed into Kosovo, the stakes there were ultimately European. Afghanistan and Iraq were about us, and I can't pretend the stakes didn't matter to me. Emotions were higher and more immediate, and the pictures and stories that came out of the war reflect that feeling.

I am part of a generation of photographers whose assignments have been in the monotone landscape of barren mountains or in the sand and desert in the Middle East. Soon after the 9/11 attacks on U.S. soil, I found myself in Afghanistan, in the carpeted rooms of modest cement homes where Al Qaeda's actions had been planned. Initially I felt anger towardS the country; but I soon understood that the people of Afghanistan were a different story. It's easy to blame a nation, but it became clearer to me that the only people who loved the Taliban were the Taliban themselves. In fact, those living under the government's strict interpretation of Islamic law had more reason than we did to wish Taliban leaders and Al Qaeda out of their country. Afghans also wanted to enjoy the simple comforts of life that we take for granted: the ability to express their religious beliefs, freedom of speech, and the right to send their children (daughters as well as sons) off to school.

Photography was also one of these banned rights. The Taliban forbade any depiction of the human form to be displayed in public. Most televisions in the country had long since been destroyed (though a few people with foresight had buried theirs on their property for safekeeping) and only Islamic music vetted by the Taliban was permitted. Abdul Waheed Wafa, an Afghan translator who works for *The New York Times*, told me a story of secretly lis-

tening to western music at the home of relatives, with the volume on the lowest setting, when the door slammed open and Taliban police stormed in, confiscating his portable CD player and violently dragging him outside to be arrested. An elderly relative pleaded frantically with them, narrowly negotiating his release from months in an Afghan prison.

When the Taliban fell, it was amazing to see how quickly the observance of their old restrictions collapsed: some wanted their pictures taken almost as rebellion against the old regime. A woman in Kabul's busy marketplace walked freely through the crowd with her burqa pulled away from her face. As I photographed her she offered no sign of objection, staring confidently into my camera's lens, an unimaginable gesture of her new freedom.

It is the tendency of every nation to cast its wars in terms of good and evil, and the war in Afghanistan was no different. Our side, the white hats, won, but this only demonstrated the complications of victory. I was traveling with one of the first groups of Northern Alliance soldiers to reclaim Kabul from the Taliban, when the soldiers captured a wounded Taliban prisoner. Without remorse, with something strangely like joy, they quickly executed him before continuing their mission south. In that moment, the fact that they were soldiers did not seem relevant. I saw our shocking lack of humanity. They—like me, like the man they shot—were all human beings. Those who died and killed there did so, not because of their passion to fight, but because they had been ordered to. And the real enemies, the masterminds with bank accounts who put pen to paper, the men who had started the terror, some of those fled east to the tribal areas at the border of Pakistan or south to strongholds in Kandahar, while others were in Washington. I wondered who had been defeated and what the conflict had cost all those it touched. In the end, perhaps good and evil exist in constant, fluid exchange, running into each other as we move beneath the pressures of the world.

Not long after the end of the war in Afghanistan, Iraq took center stage. For several months I was an American behind enemy lines, photographing what turned out to be the last days of Saddam Hussein's regime. Iraqi civilians expected to get hit—yet again—by American bombs, but in the weeks before the war the civilians remained friendly. They had no access to the news and asked the journalists where the bombs would fall—questions to which we had no answers. (Were they just being curious in a naturally hospitable country, or secretly rooting for invasions in a context where the terror of the Saddam State was so effective that subversive thoughts were only obliquely expressed?)

Unlike the chaotic conditions of Afghanistan (where we were mostly free to cover the conflict in the north as we chose), photographers and journalists in Hussein's Iraq were subjected to the same restraints as the Iraqi population. We were teamed with government-appointed "minders," whose job was to keep us from seeing and keep us from documenting all they wanted to hide. This covered a great deal, including Saddam's presidential palaces, major bridges, and power plants. We were also not allowed to photograph any sign of poverty, including underprivileged people or poor

neighborhoods including Saddam City, since renamed Sadr City. Letters of permission had to be drawn up by the government's press center whenever we wanted to venture out. Violating the rules of working media meant jeopardizing the renewal or extension of our visas and held with it the risk of being thrown out of Iraq before the great story of the seemingly inevitable fall of Baghdad unfolded.

On March 20, 2003, that story began—bombs began to fall. At night we photographed the first cruise missiles crashing into the Palace of the Republic—photographs that Iraqi authorities tried (in vain) to stop. By day we saw the terrible aftermath: large numbers of Iraqi civilians also hit by those bombs—and took photographs of the ugly side of war seen around the world. These photographs meant most to me; so, I focused on the people whose lives were shattered and so quickly forgotten.

I had two concerns of my own: I didn't want to get killed by the American bombs being dropped from overhead, and I couldn't rule out the possibility that as the Iraqi regime faltered they might collect foreigners as human shields (which happened to others during the Gulf War). Before the fall, our exposure to Baghdad had been limited to state-monitored bus tours of the city that were comical; sometimes we were driven in circles only to be returned to our hotel fifteen minutes later. As American and British troops closed in on the capitol, boarding the buses now became a source of paranoia. Grouped together we were obvious targets for capture or bombs.

We were not the only ones getting nervous. A week before the American arrival, familiar faces from the regime began disappearing. One of our minders, an ex-general in the Iraqi Army who had been shot through the hand by a G.I. in Kuwait during the Gulf War, made a final visit to our room at the Palestine Hotel with others from the Ministry of Information. Wearing black leather jackets and pistols in their belts, the soldiers snatched our laptop computers, satellite telephones, cameras, cash, and even cans of tuna and chocolates from our food supply, before vanishing forever.

We thought order would break down in Baghdad as the Americans approached, but it didn't happen quite that way. Just hours before the arrival of foreign troops, the press center still functioned confusedly under the umbrella of the Iraqi Ministry of Information and Iraqi officials continued to deny that they were losing control of the city. It was not until the final moments that the last vestiges of authority disappeared from the lobby of the Palestine Hotel.

Photographers and writers, all the international press in Baghdad, emerged from the smoke and haze to have their first uncensored and unaccompanied look at Iraq. We thought at the time that the fighting was behind us; but, we soon learned that it had not even begun....

—TYLER HICKS
BAGHDAD, IRAQ. SEPTEMBER 2004

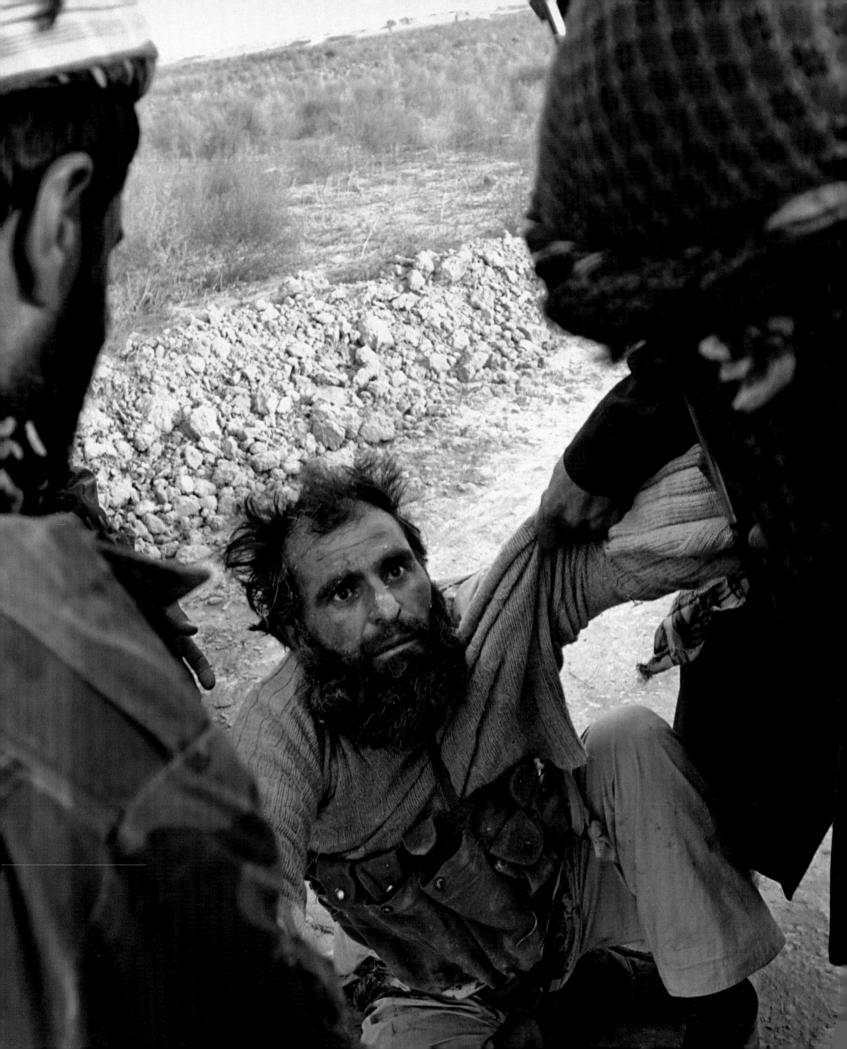

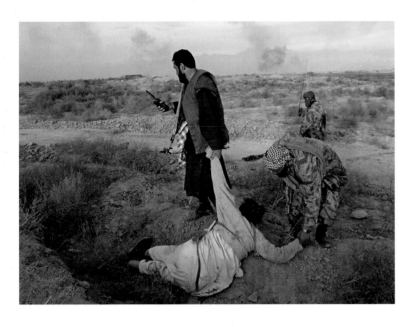

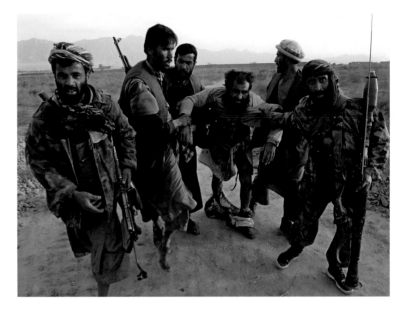

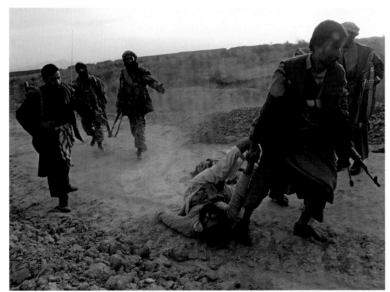

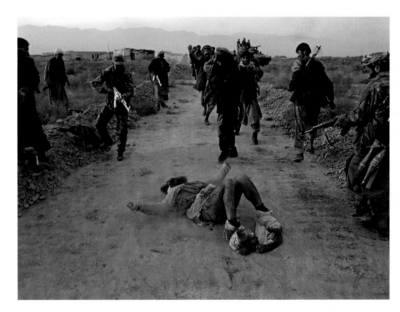

QALI-I-NASRO, AFGHANISTAN. NOVEMBER 12, 2001

The Northern Alliance finds a Taliban soldier, lying motionless and bleeding on the side of a dirt road and search his body for useful belongings. They discovered that he had been shot in the upper leg, but otherwise was alive and had remained still, hoping to be overlooked in the confusion of the advance. After being rousted to his feet, a growing and excitable group of Northern Alliance soldiers harassed their new prisoner, yelling and dragging him along the dirt road back in the direction of a trench where their commander was continuing the fight. The prisoner's loose-fitting pants fell to his feet which further added to his

humiliation. The soldiers were shouting into their two-way radios and the order quickly came. Three men simultaneously raised their Kalashnikov rifles and fired numerous rounds into the chest and head of the soldier, whose death quickly dampened the excitement of the group. They continued on their way among the dust which still hovered from their gunfire.

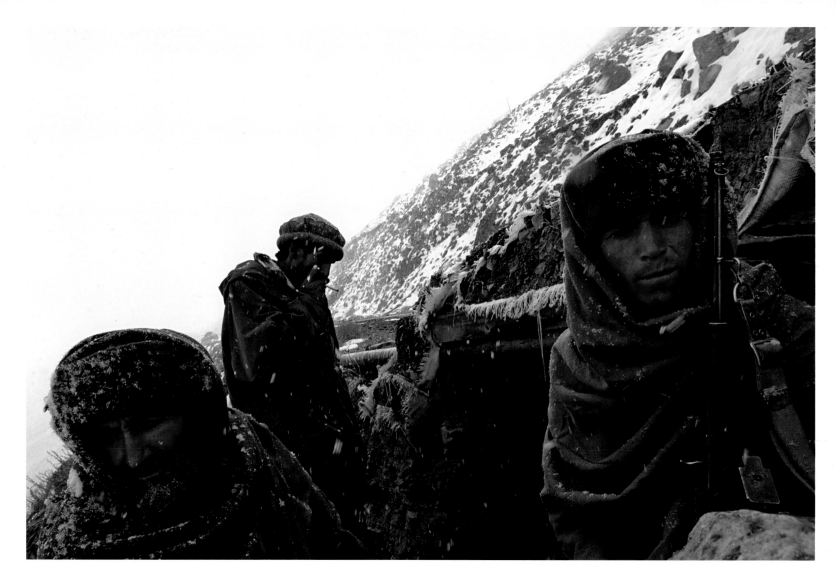

SALANG, AFGHANISTAN. NOVEMBER 9, 2001

The Salang tunnel, leading to the Salang Pass, was originally constructed by Russian contractors during their occupation in the 1980s and served as a makeshift barricade to keep snow from the steep mountainside from sliding down and blocking the road. On their retreat from the country, the Russian military detonated bombs and blew up tons of equipment inside the tunnel to make it impassable. The resulting journey, accomplished only by foot, required an hour of navigation in darkness through twisted steel and cables, jagged cement and ice. The far side held a small Northern Alliance outpost, where poor and underequipped soldiers took shifts in the high winds and snow to keep watch on Taliban positions in the distance. Years later, in 1998, the Salang Pass was largely destroyed in fighting between the Northern Alliance and the Taliban. Cleared in 2002, it is now a vital north-south path.

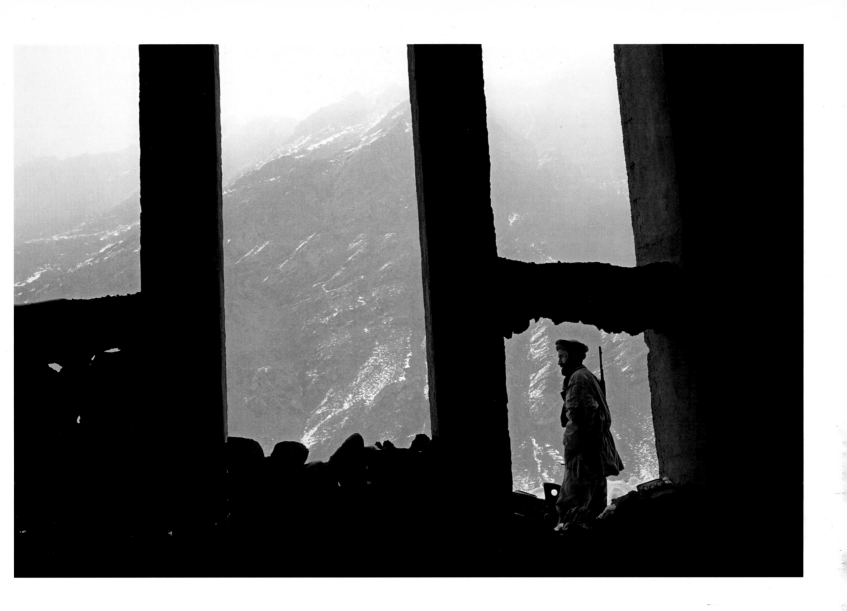

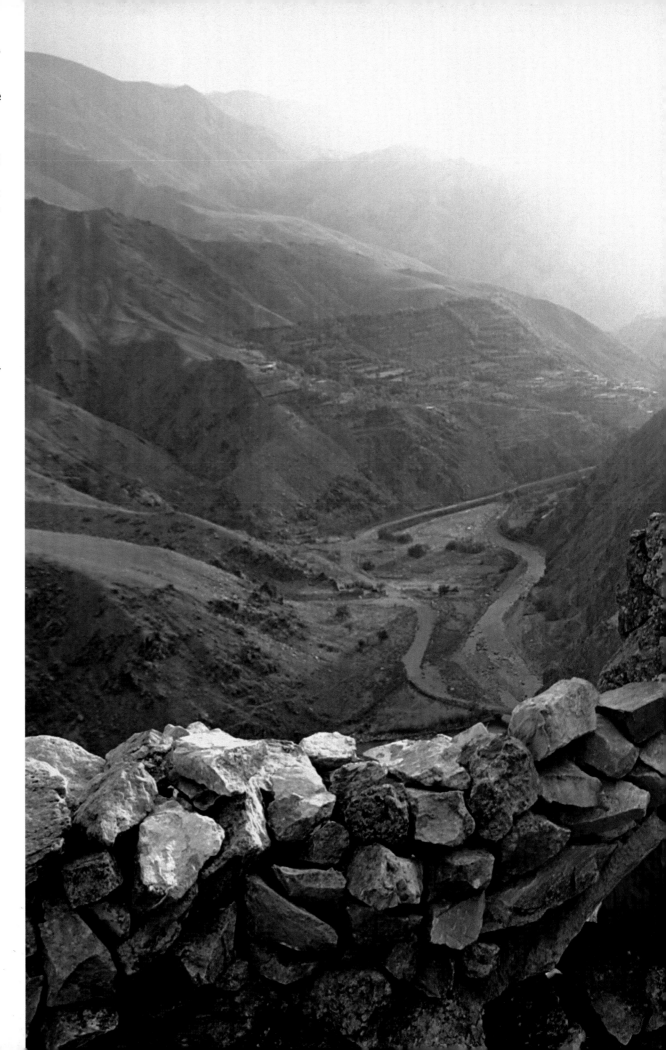

GHORBOND, AFGHANISTAN. OCTOBER 18, 2001

Northern Alliance soldiers look down onto the Taliban-controlled village of Ghorbond. The rocky terrain made transport of soldiers and their equipment a challenge. Also problematic was the condition of the defenders' weapons, many of which were liberated from the Russians during and after their failed occupation in the 1980s. That war cursed Afghanistan with more land mines than any country on earth, a terrible legacy that will continue to kill and maim civilians for years to come.

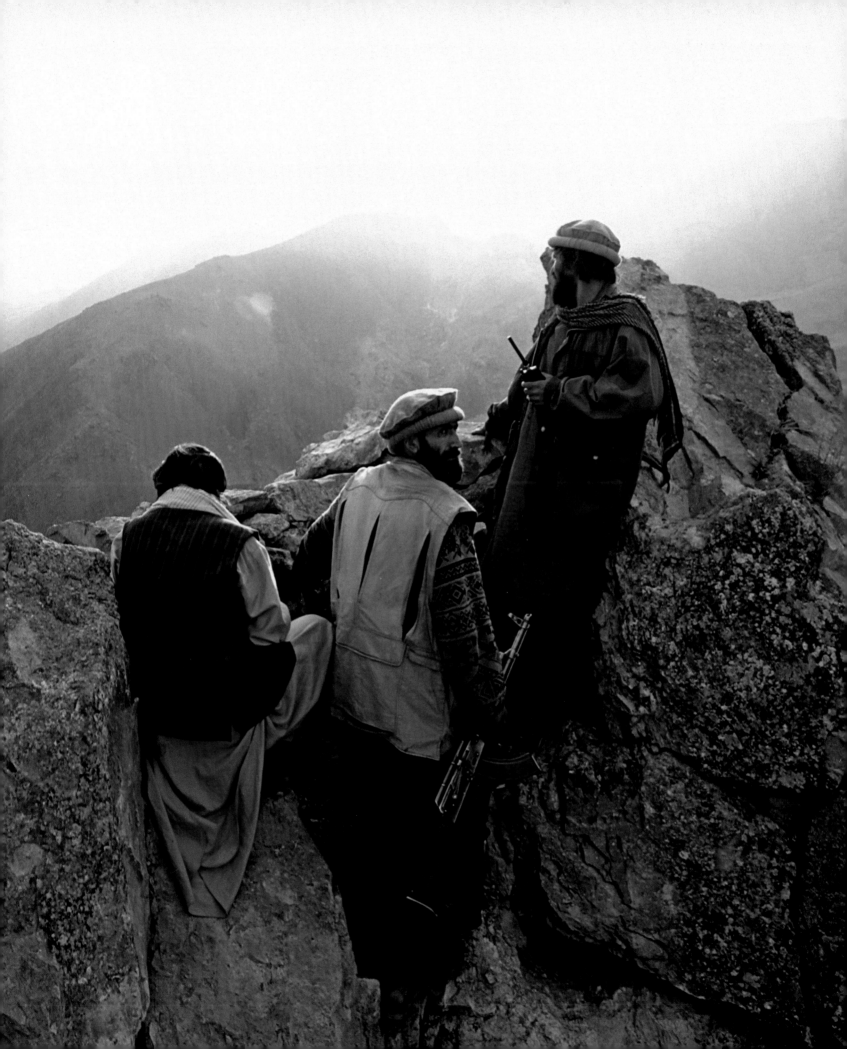

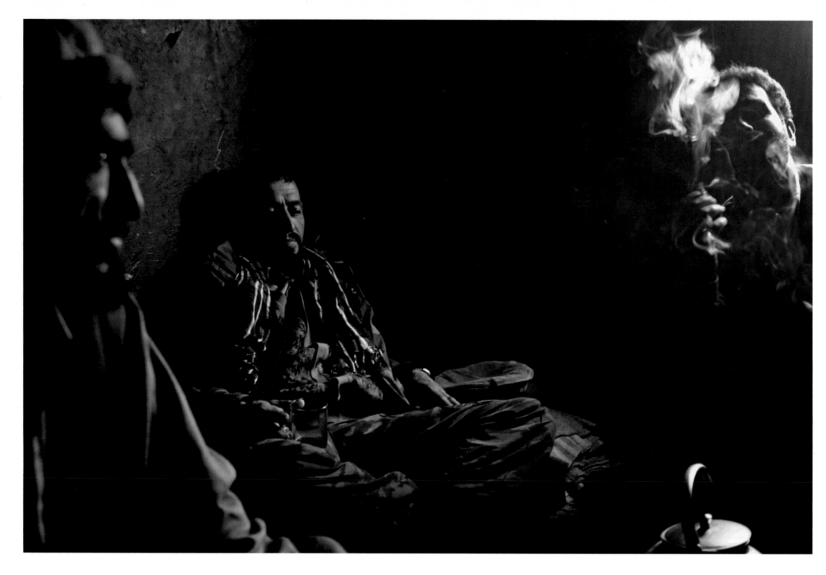

SALANG, AFGHANISTAN. NOVEMBER 9, 2001
Northern Alliance soldiers warm themselves with tea and ciga-
rettes after a shift at the base.

SHEBERTOO, AFGHANISTAN. DECEMBER 5, 2001
As cold weather set in and with food in short supply, many
Hazaras living in Shebertoo near Bamiyan face a bleak and diffi-
cult winter. The Hazara tribespeople are religious and ethnic
minorities in Afghanistan, due to their ancient Asian and
Buddhist heritage. Following the Taliban retreat, after five years
in power, the weight of the devastation they wrought was clear.
During the Taliban rule thousands of Hazaras were killed in a
classic instance of ethnic cleansing. One hundred years ago
Pashtun emir Abdul Rahman, offended not only by the Hazara
religion but also by their independence, made their massacre a
central part of his autocratic rule. The Taliban followed in his
footsteps.

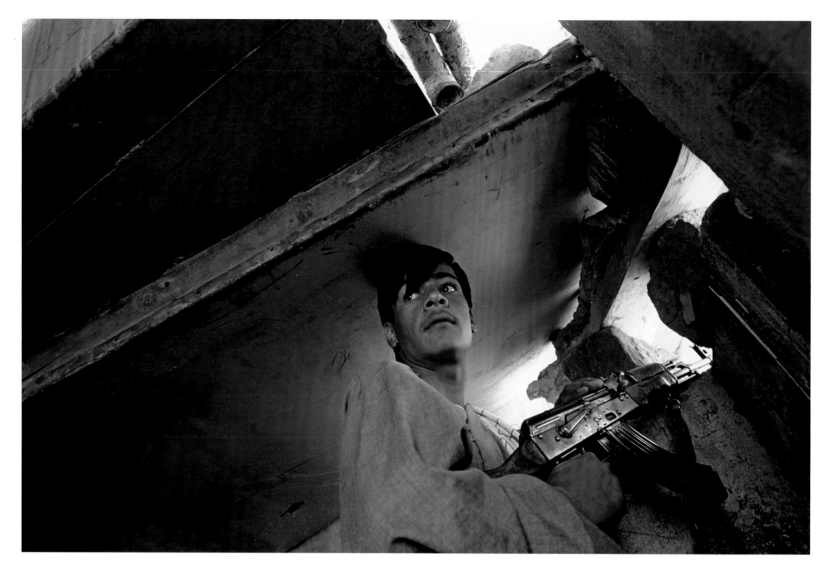

BAGRAM, AFGHANISTAN. OCTOBER 31, 2001
Zaman, an eighteen-year-old Northern Alliance soldier, bunkered
in a former movie theater, alerted others after spotting activity on
the Taliban front line. In what became a round-the-clock bomb-
ing campaign to weaken the Taliban, American B-52s and fighter
jets dropped bombs across Tota Khan Mountain, where Taliban
positions were hit on what was among the most strategic bases
for the Taliban because of its proximity to the capitol.

BAGRAM, AFGHANISTAN. OCTOBER 31, 2001
Northern Alliance soldiers watched as the American planes made
passes overhead. The Northern Alliance supported the American
involvement in the war, as it enabled the defeat of the Taliban
and brought an end to civil war.

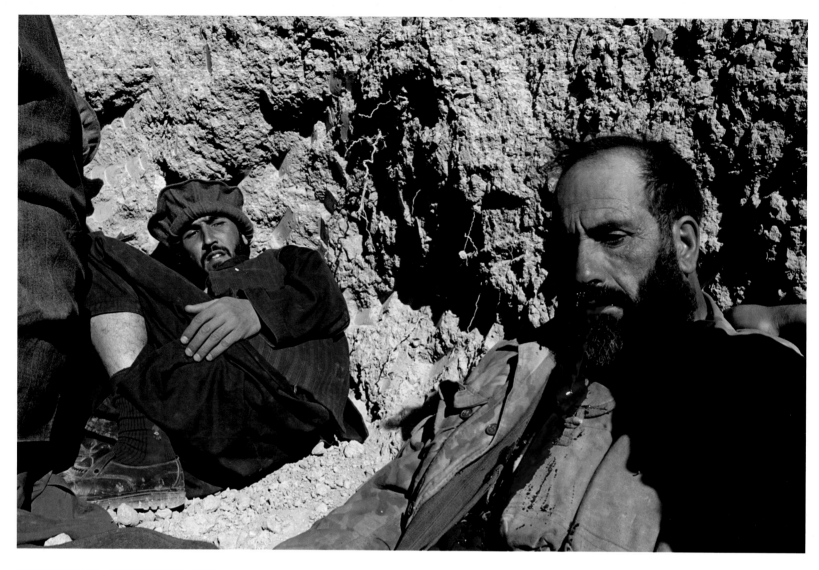

MAIDAN SHAHR, AFGHANISTAN. NOVEMBER 22, 2001

A dying Northern Alliance soldier named Amin, shot moments earlier in the chest after running for cover and jumping into a trench in Maidan Shahr, twenty miles southwest of the capitol Kabul. Following a week of failed negotiations, about 500 Northern Alliance soldiers attacked the province, which is a Pashtun stronghold. The Taliban, trapped in villages from two sides, were able to fend off the Northern Alliance and forced them to retreat. Several Northern Alliance soldiers were killed and others injured in the fighting, which began at around 8:30 am, and lasted until the early afternoon.

Following a week of failed negotiations brokered between village elders, an attack on the Taliban was mobilized. At an abandoned house which served at their impromptu base of operations, soldiers passed the time during this month of Ramadan when no food or drink could be taken until sunset by plucking a stray chicken. They received orders early in the morning to prepare to attack. Soon hundreds of new troops arrived, packed into the backs of old trucks or riding inside armored personnel carriers, and gathered outside the house, which rested on the last stretch of paved road south of Baghdad just before turning to dirt and gravel. Just west of the house a lightly traveled dusty path curved around the beginning of the hills and into a barren, flat valley where the Taliban had been steadfastly holding their

ground. The trucks and APCs led the way, and as they disappeared into the valley explosions could be heard as smoke rose from the horizon. Armed Northern Alliance soldiers followed the vehicles on foot, confidently walking along the road towards the fighting, meeting no resistance. Only when the Northern Alliance soldiers had advanced into the open did the Taliban, invisible from their vantage point in the hills above, opened fire on the men, sending them scattering for cover. Blindly firing in retaliation, the soldiers ran off the road to take cover in shallow fox holes, previously dug out by the Taliban. The commander made a motion with his arm for the soldiers to stay down. At this point Amin sat up to peer from the hole, then slumped back into a seated position. Blood began to flow from his mouth, pumping with each heartbeat as his lungs filled after being shot in the chest. As the color from his face faded, other soldiers loaded the dying soldier onto the back of another, who ran him back out of the valley. The Northern Alliance, at a great disadvantage to the dug-in Taliban, retreated. Several days later a peaceful deal was finally agreed upon and the Taliban laid down their arms, free to return to their villages or change sides, as so many did during this time.

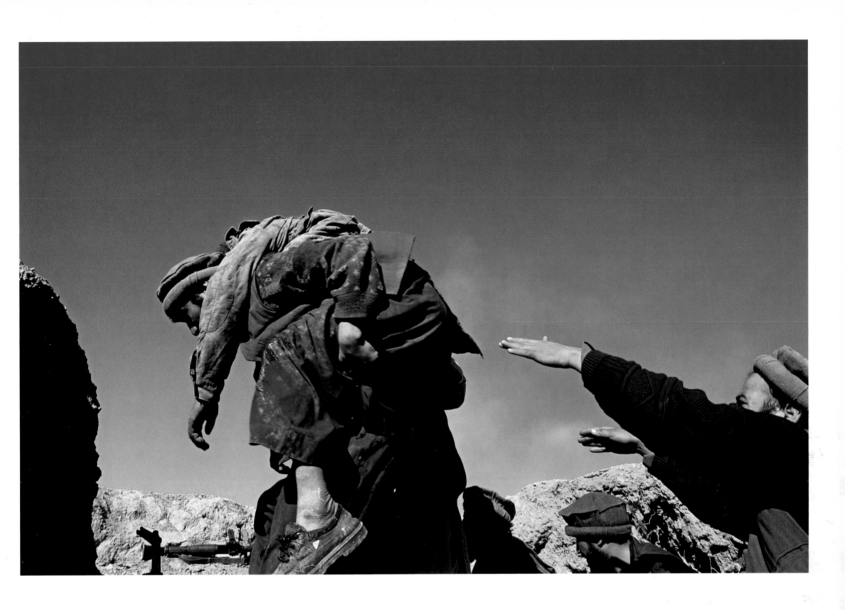

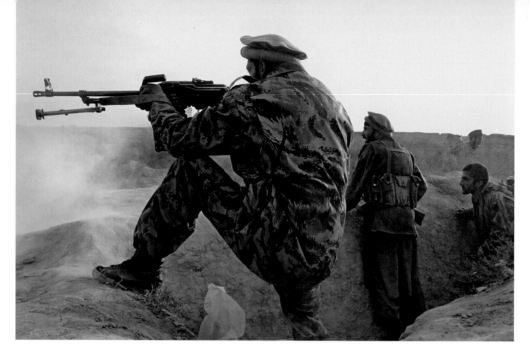

Top row left and far right:
QALA-I-NASRO, AFGHANISTAN. NOVEMBER 12, 2001
Smoke from American airstrikes rises on the horizon as Northern Alliance soldiers fire on Taliban soldiers advancing through the village of Qala-i-Nasro toward Kabul. The attack was launched after noon from several front lines and continued until dark.

Bottom row, right:
Northern Alliance soldiers with guns, blankets, and other goods looted from the village.

Top row, center; middle row left and center:
MAIDAN SHAHR, AFGHANISTAN. NOVEMBER 22, 2001
Northern Alliance soldiers run for cover as they take heavy incoming fire from Taliban soldiers.

Middle row, right; bottom row left:
CHESHMA KHAROTI, AFGHANISTAN. NOVEMBER 19, 2001
The bodies of Taliban soldiers lay near the village of Cheshma Kharoti, about twenty miles north of the capitol. Several bodies showed signs of execution.

Bottom row, center:
KHOJA BAHOUDIN, AFGHANISTAN. OCTOBER 6, 2001
Northern Alliance soldiers load a truck near the village of Khoja Bahoudin on their way to the front line.

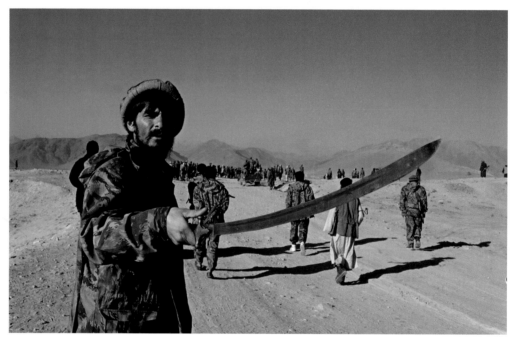

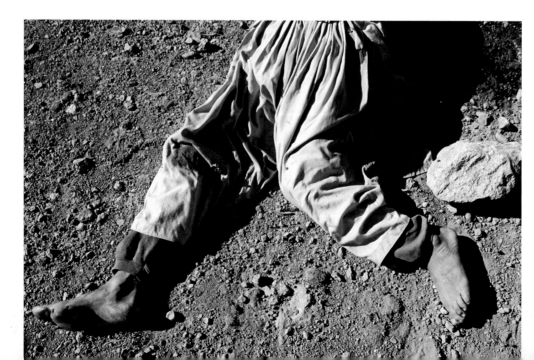

26

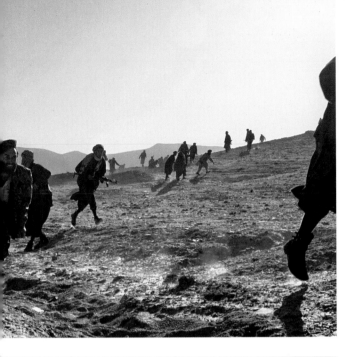
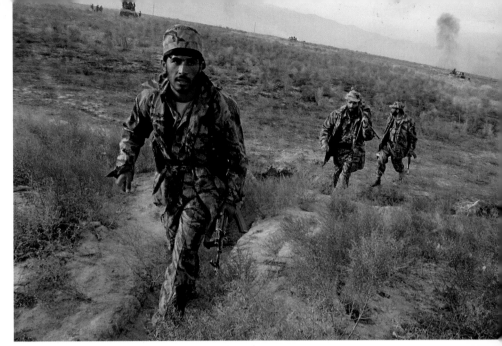
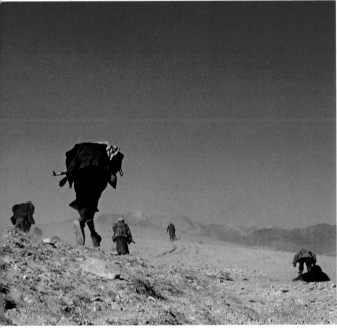
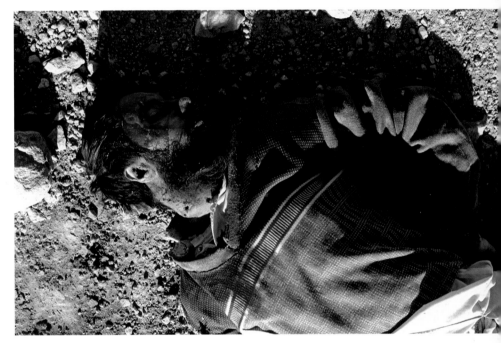
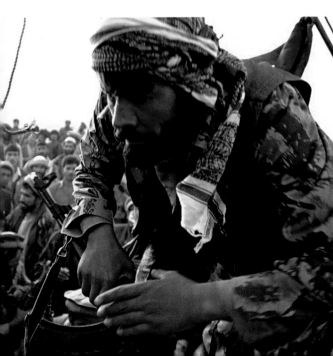
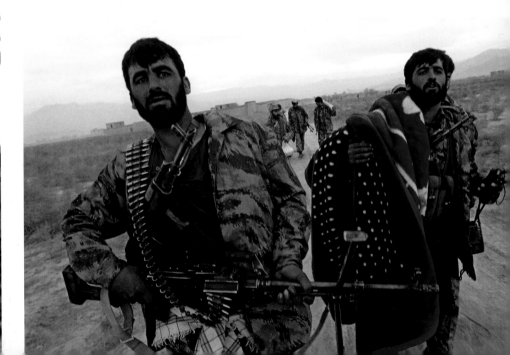

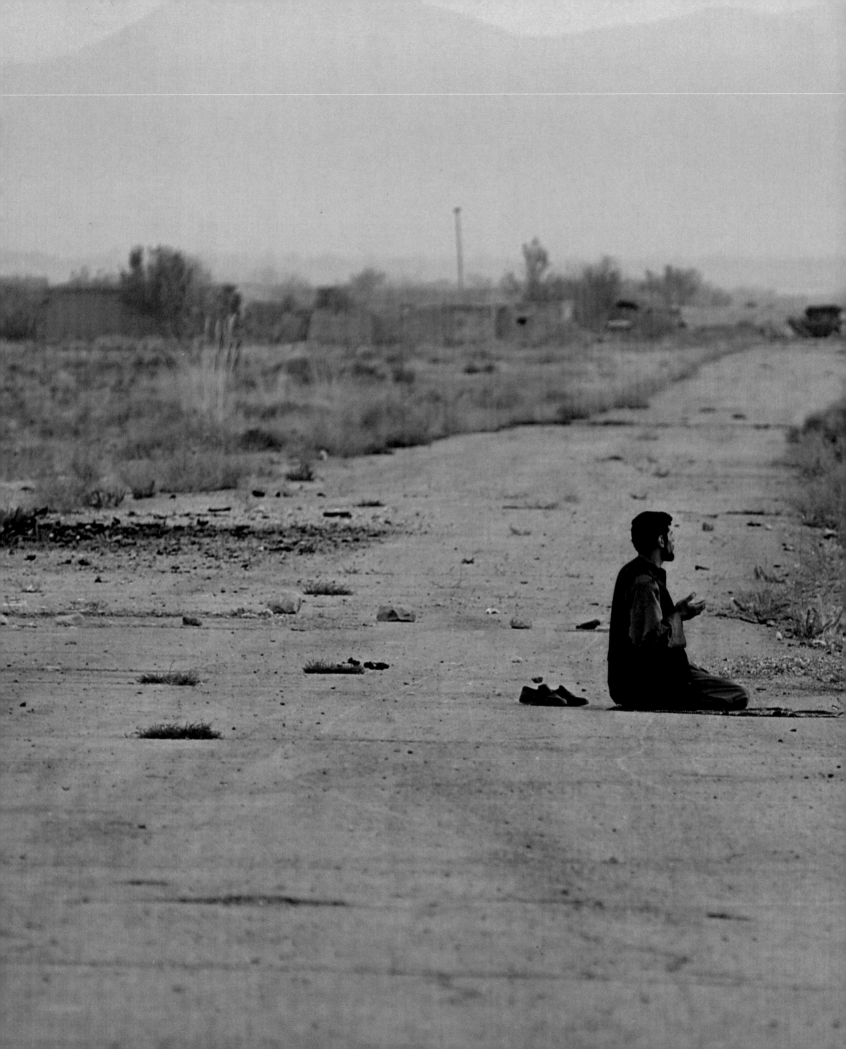

**RABAT, AFGHANISTAN.
OCTOBER 29, 2001**
A Northern Alliance soldier prays on the old Kabul road about 350 yards from a Taliban front line. Littered with the debris of years of war, the road was a strategic point of control and, once cleared of old debris and makeshift roadblocks, opened the north to the capitol.

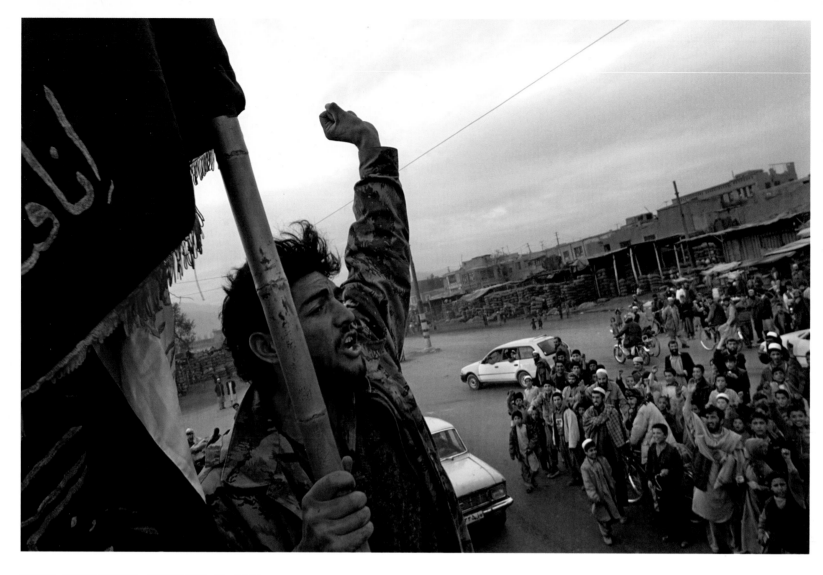

KABUL, AFGHANISTAN. NOVEMBER 13, 2001
The Northern Alliance advanced to the northern limits of Kabul,
where they gathered before making the final push into the capi-
tol. Upon arrival in the city center a Northern Alliance soldier
yells to gathering civilians from the back of a truck as they drive
in celebration after liberating the city from the Taliban. The
Northern Alliance faced limited resistance, since many Taliban
had already fled either east to the tribal areas of Pakistan or to
Kandahar, the Taliban's stronghold in the south. The United
States military took advantage of the disarray of the Taliban,
bombing their retreat. Despite the magnitude of the day's
events, life continued normally, with roadside shops selling food
and supplies and other businesses remaining open.

KABUL, AFGHANISTAN. NOVEMBER 13, 2001
A soldier holds a portrait of Ahmed Shah Massoud, venerated
commander of the Northern Alliance, who was assassinated by a
bomb concealed inside a video camera during an interview with
infiltrators posing as journalists. Knowing there would be retalia-
tion by the United States and their enemies in Afghanistan, Al-
Qaeda killed Massoud to throw the Northern Alliance into disar-
ray just days before 9/11.

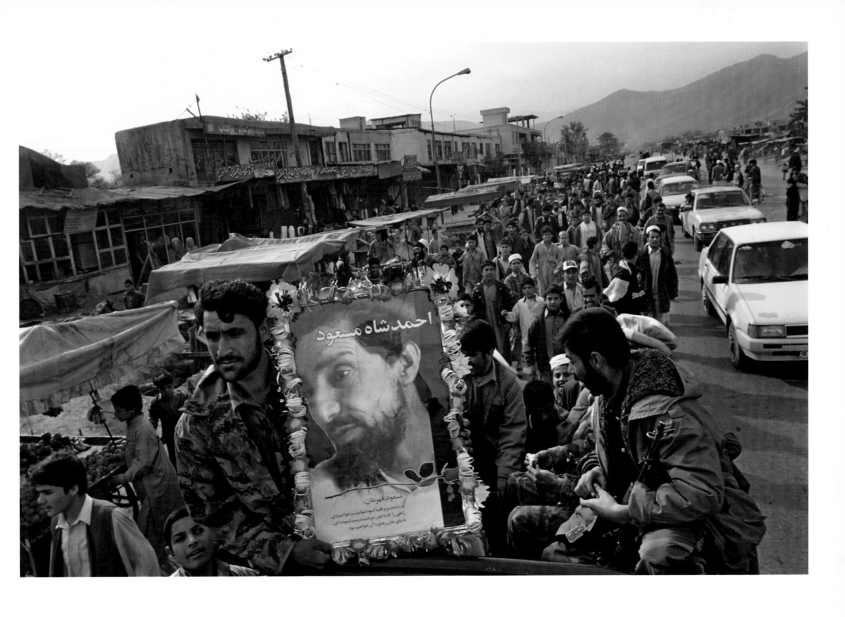

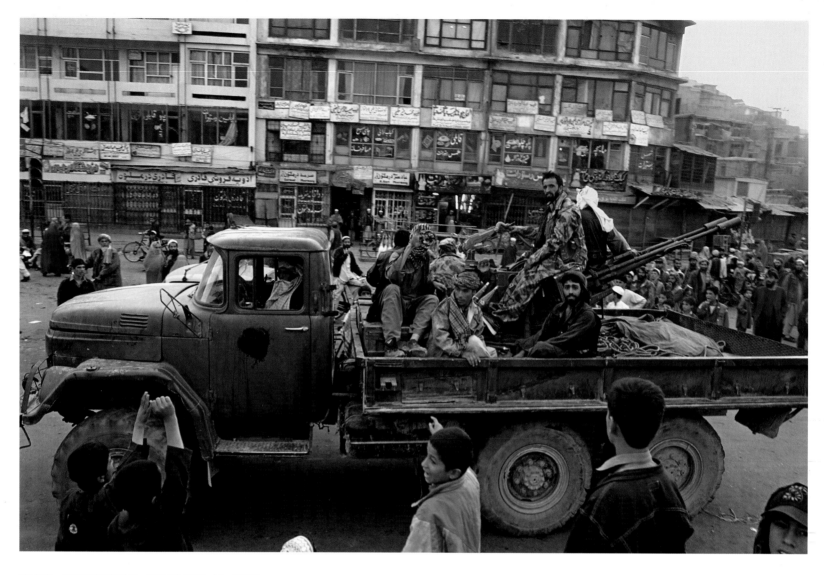

KABUL, AFGHANISTAN. NOVEMBER 13, 2001
Soldiers parade through the streets of Kabul after its liberation
from Taliban rule.

SHIBERGHAN, AFGHANISTAN. NOVEMBER 13, 2001
Thousands of men who had fought with the Taliban are crowded
into a prison in Shiberghan. The halls separated Afghan prison-
ers from Pakistani prisoners in a vast and crowded complex
which held the men as de-facto P.O.W.s in a country where nine-
ty percent of the population was under Taliban control and many
had been forced into fighting. Throughout the detention center,
the men passed most of the day reading the Koran or praying.
Others carried on with daily life, washed clothes and set up shop
selling small items like cigarettes, soap, and crackers.

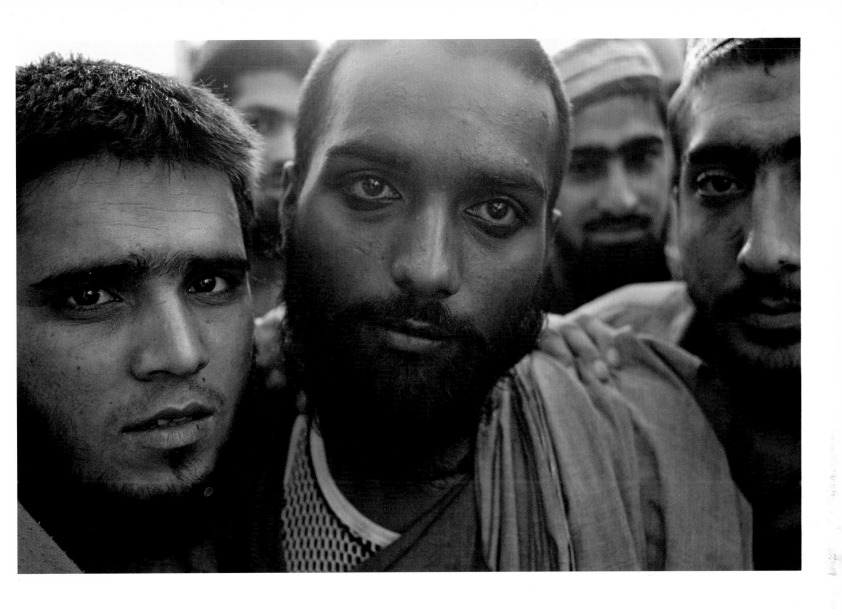

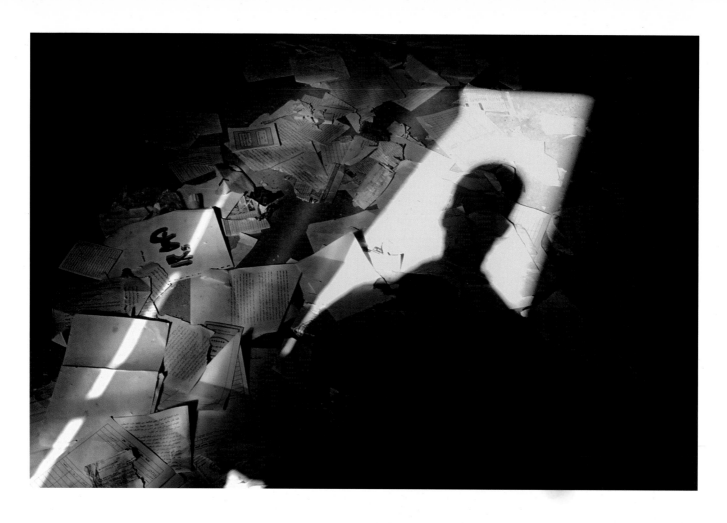

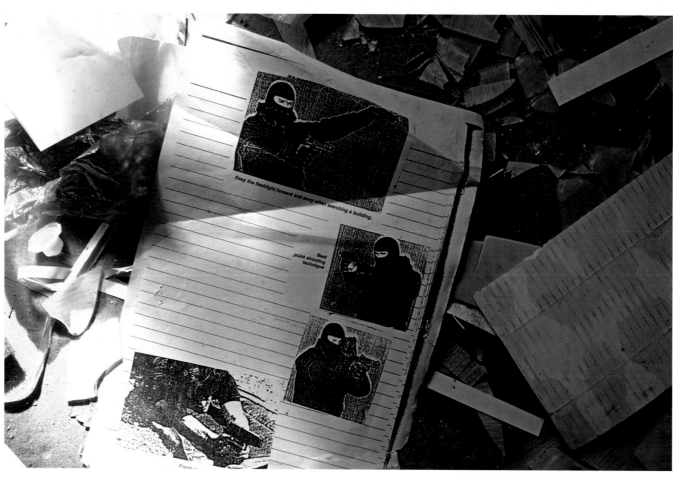

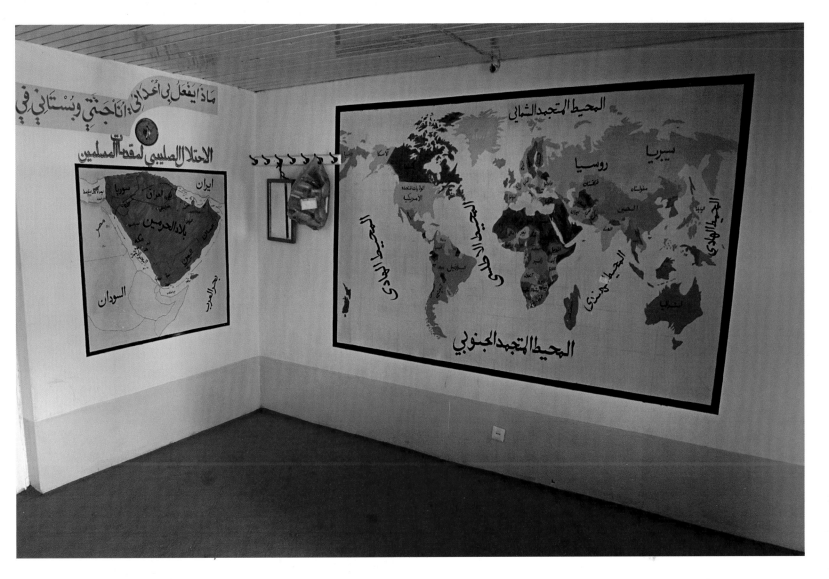

KABUL, AFGHANISTAN. NOVEMBER 16, 2001
Documents scattered on the floor of a house of a suspected Al
Qaeda base included a page torn from a flying magazine with
flight training ads, a map of Afghanistan, packaging from a copy
of flight simulation software, and detailed notes written both in
Arabic and English. Maps painted on the walls locate American
military bases abroad.

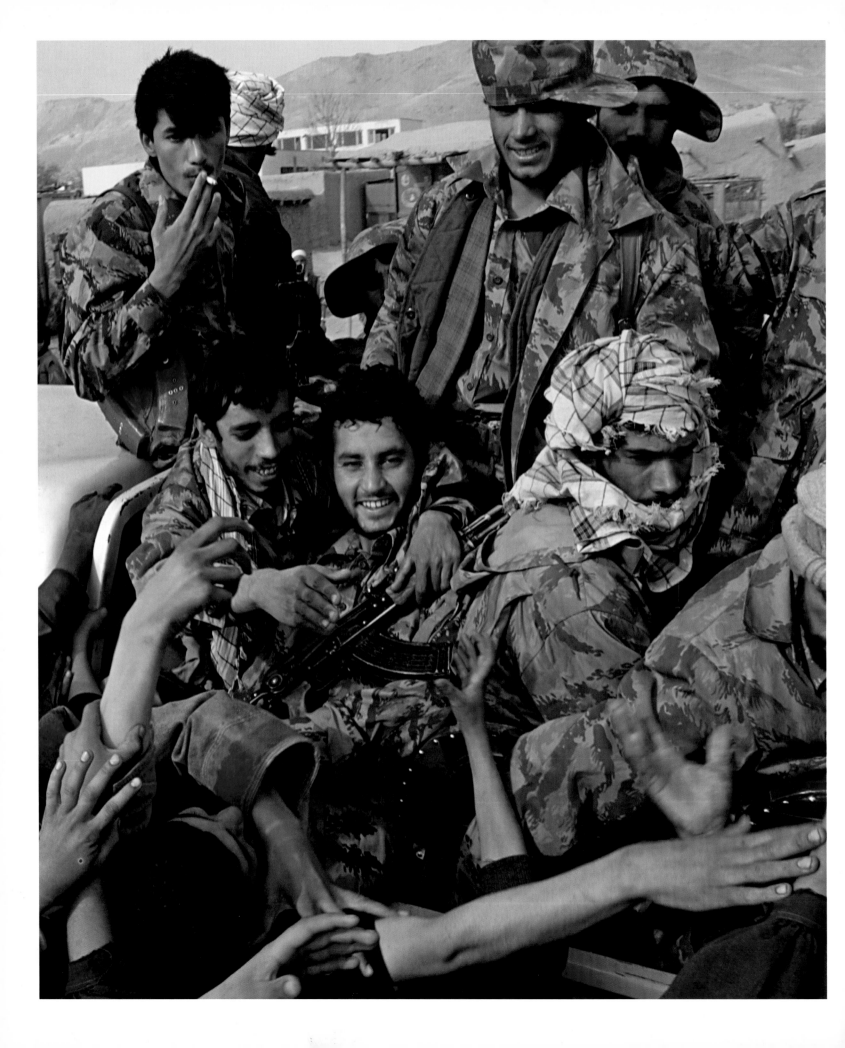

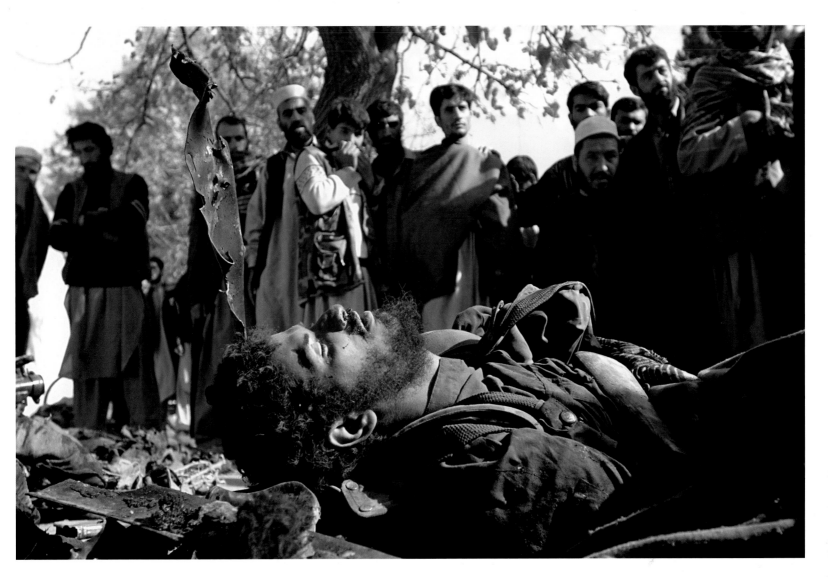

KABUL, AFGHANISTAN. NOVEMBER 13, 2001
After stalling an advance which had begun the day before, the
Northern Alliance reached the city limits of Kabul before making
a final push into the capitol.

KABUL, AFGHANISTAN. NOVEMBER 13, 2001
As the Northern Alliance entered Kabul, some of those who did
not have the foresight to flee met a violent end. A house full of
Arab fighters blew themselves up with bombs when there was no
chance of escape. Others fled into a wooded park and tried to
hide in the trees. The angry crowd, many of whom were armed
civilians and who had lived side-by-side with the Taliban until
this day, shot them down from the trees, and then gathered while
others kicked and spit on the still-breathing men, in one case
stabbing a man in the eyes with a pocket knife while he was still
alive. All non-Afghan fighters, notably Arabs and Pakistanis who
remained in the country, were quickly killed or arrested.

MADOO, AFGHANISTAN. DECEMBER 15, 2001

Residents of Madoo, Afghanistan stand among the graves of fifty-five civilians killed when errant American bombs were dropped on this village. Fifteen houses were crushed in the attack, which involved multiple strikes by an U.S. aircraft. The Pashtun village is within miles of the Tora Bora cave complexes, which had come under fierce bombing to rout out the remaining Taliban (believed at the time to be a possible location of Osama bin Laden).

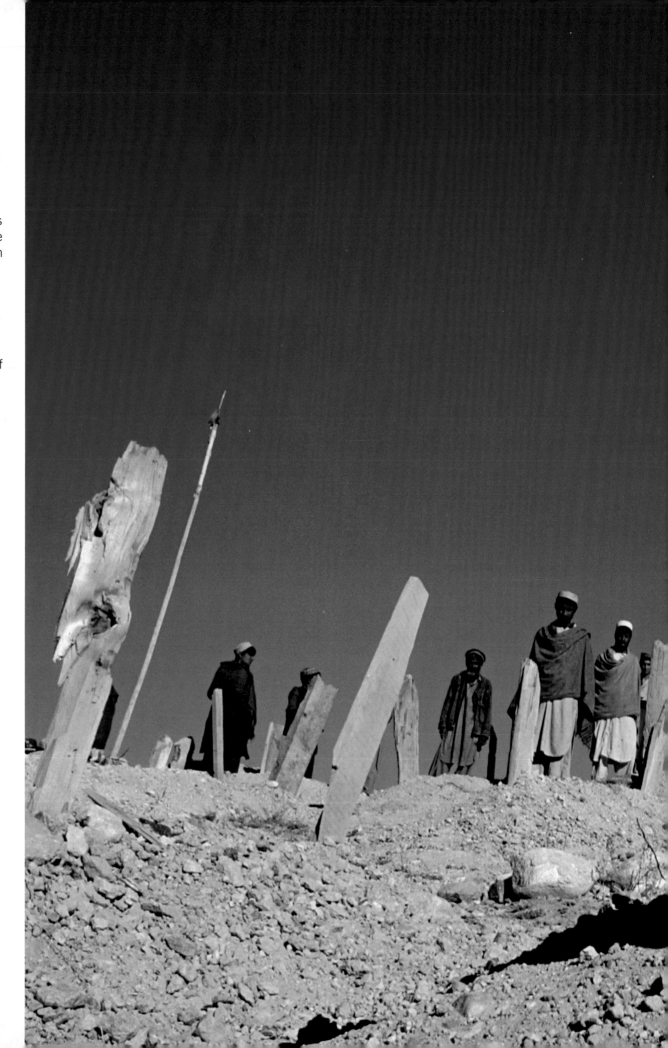

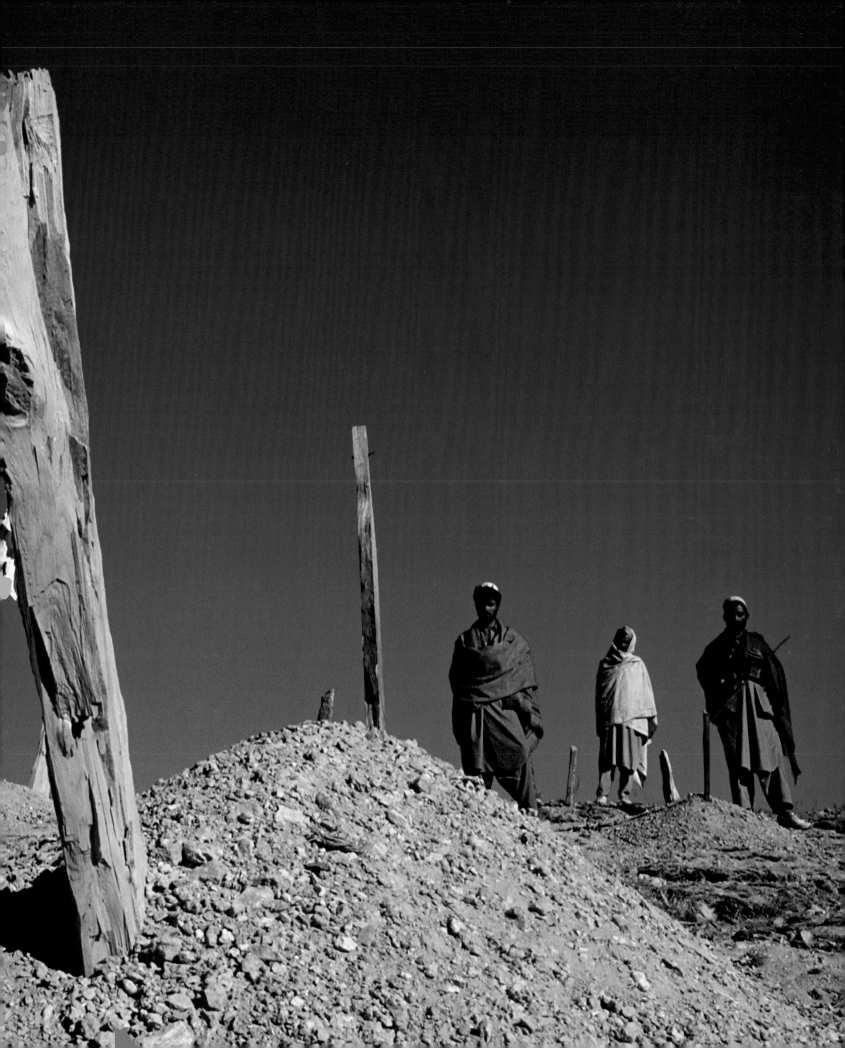

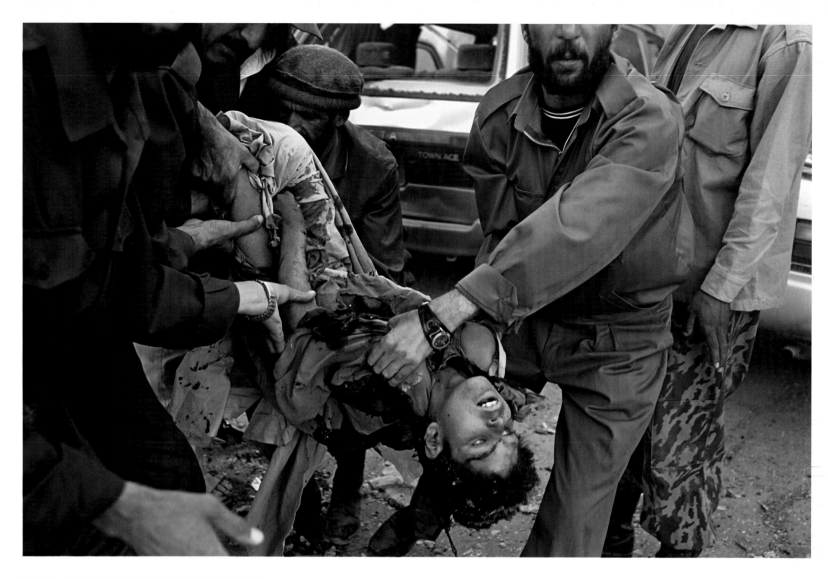

KABUL, AFGHANISTAN. SEPTEMBER 5, 2002
Afghan civilians and police rush a dead boy to a vehicle immedi-
ately following a bomb blast timed to the anniversary of the
assassination of Ahmed Shah Massoud, leader of the anti-Taliban
resistance who became an icon of post-Taliban Afghanistan and
the 9/11 attacks in the United States. Running down to the
Kabul River, the busy street where the bombing took place is
lined with electrical appliance shops, fruit vendors and other
goods sold from handcarts. A small bomb, detonated in a bag
attached to a bicycle, drew the curious crowd closer when the
main bomb, concealed in a car, exploded, sending the bodies of
dozens of men, women, and children, many badly burned, across
the road among pools of blood and broken glass. "Al Qaeda and
the Taliban are trying to show they are not fully destroyed. The
message today was to their own audience, to their own con-
stituents, to extremist groups around the world, that despite all
that has happened, they are still capable of these kinds of inci-
dents," Afghanistan's Foreign Minister Abdullah said at a news
conference in Kabul after hearing about this and an assassina-
tion attempt on Afghan President Hamid Karzai.

KABUL, AFGHANISTAN. NOVEMBER 13, 2001
A father escorts his son to view the body of a young Taliban sol-
dier stripped of his belongings and tossed into a drainage ditch
after Kabul was liberated by Northern Alliance fighters

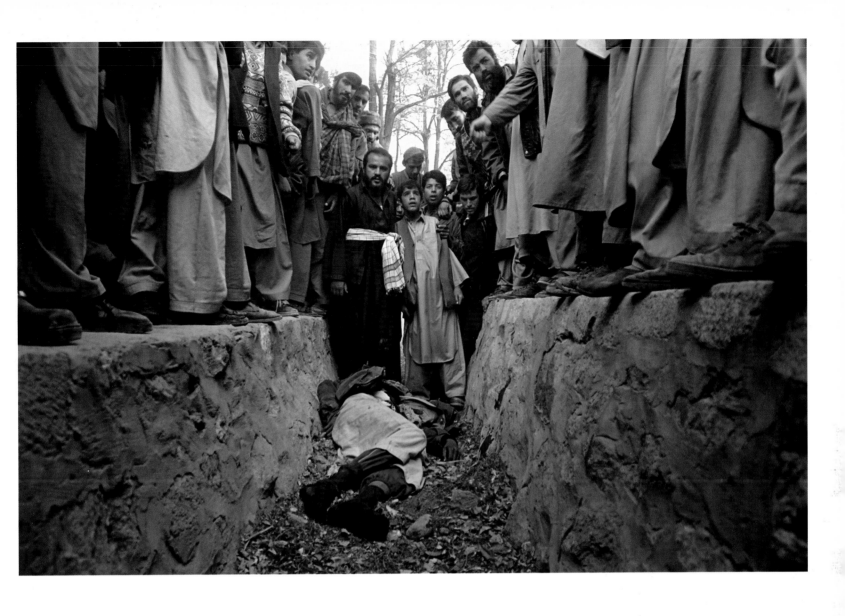

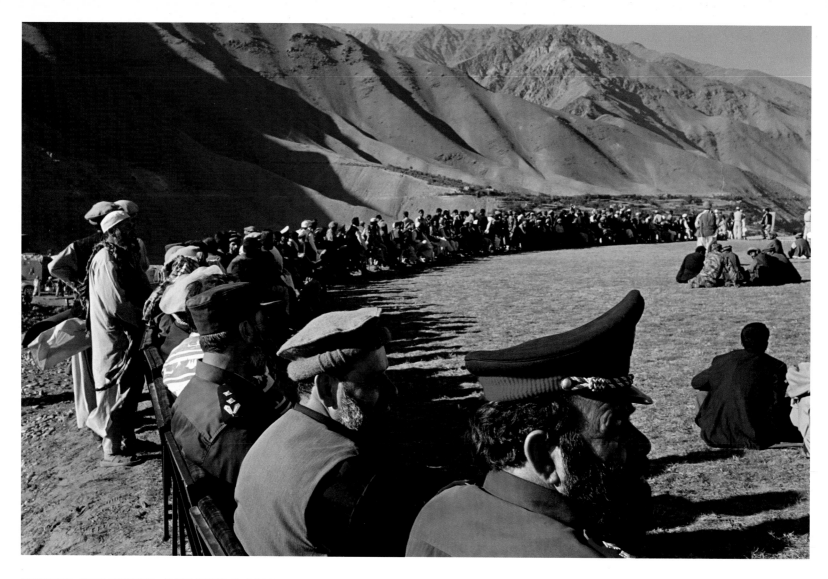

BAZARAK, AFGHANISTAN. SEPTEMBER 9, 2002
Afghans visit the burial site of Ahmed Shah Massoud in the village of Bazarak in Panshir on the anniversary of his assasination to pay their respects to the late commander.

BAZARAK, AFGHANISTAN. SEPTEMBER 7, 2002
Afghan President Hamid Karzai during his visit to the burial site of Ahmad Shah Massoud.

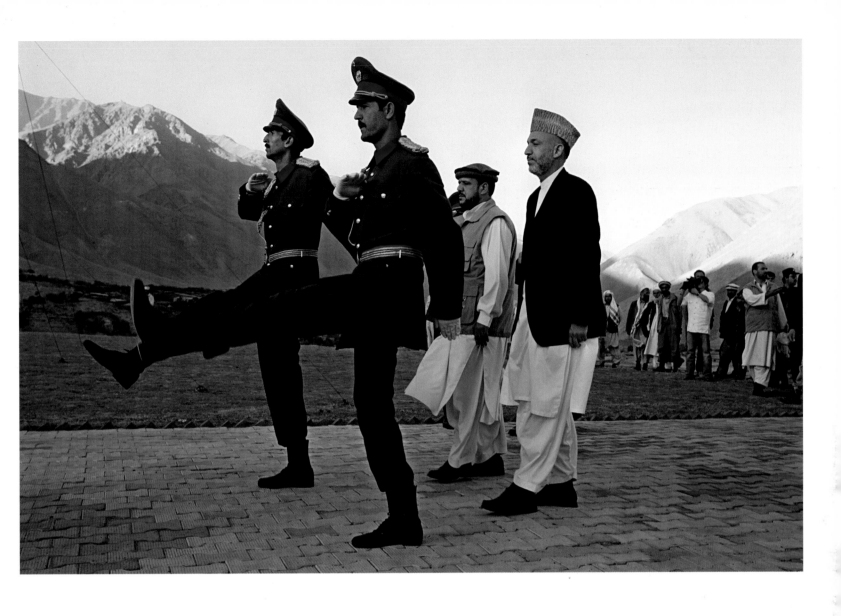

Top row, left to right:
GHAZNI, AFGHANISTAN. DECEMBER 11, 2001
Two guards of Qari Baba, Governor of this former Taliban stronghold.

KHOST, AFGHANISTAN. AUGUST 5, 2002
Mohamed Yunos, supporter of warlord Padsha Khan Zadran who rejects the new Afghan government of Karzai.

Bottom row, left to right:
KABUL, AFGHANISTAN. AUGUST 15, 2002
Outside her room at Marastoon, a charity run by the Afghan Red Crescent which houses and feeds the poor while teaching them basic living skills as well as workshops for weaving carpets and knitting. During Taliban rule women were not allowed in this facility; now the majority of its population is female.

KABUL, AFGHANISTAN. SEPTEMBER 13, 2002
A burqa shop in Kabul. Ten months after Taliban rule collapsed.

GHAZNI, AFGHANISTAN. AUGUST 26, 2002.
Despite death threats Afghan girls attend a school one year after they fled this village which the Taliban had captured in 1995.

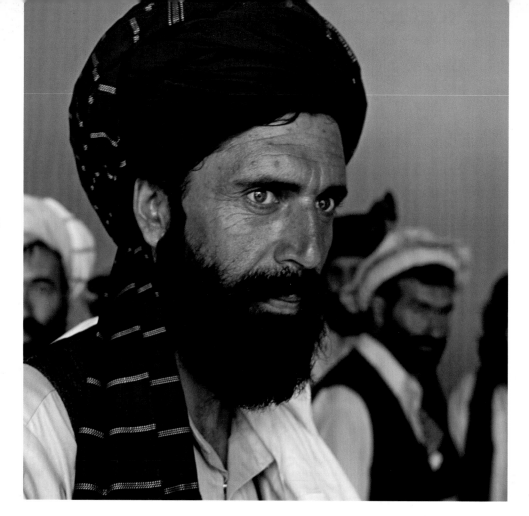

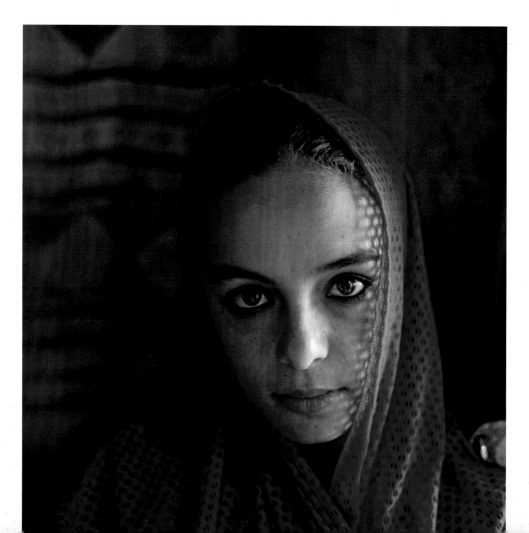

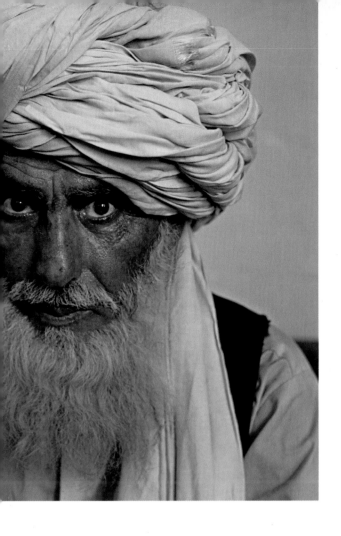
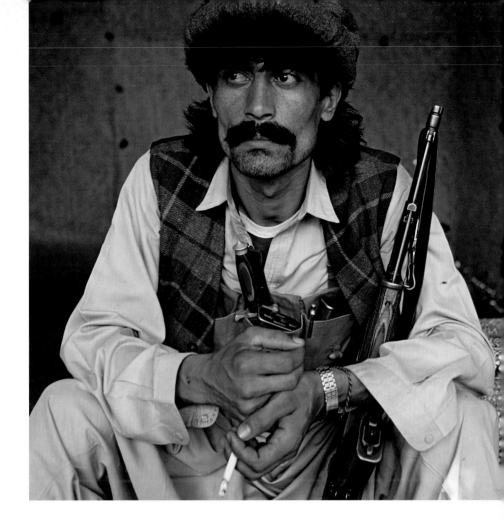

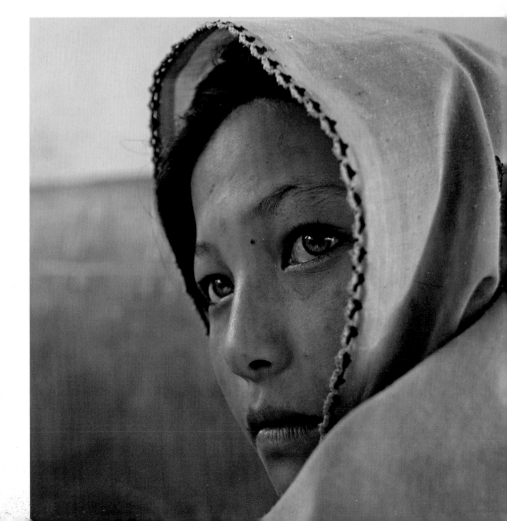

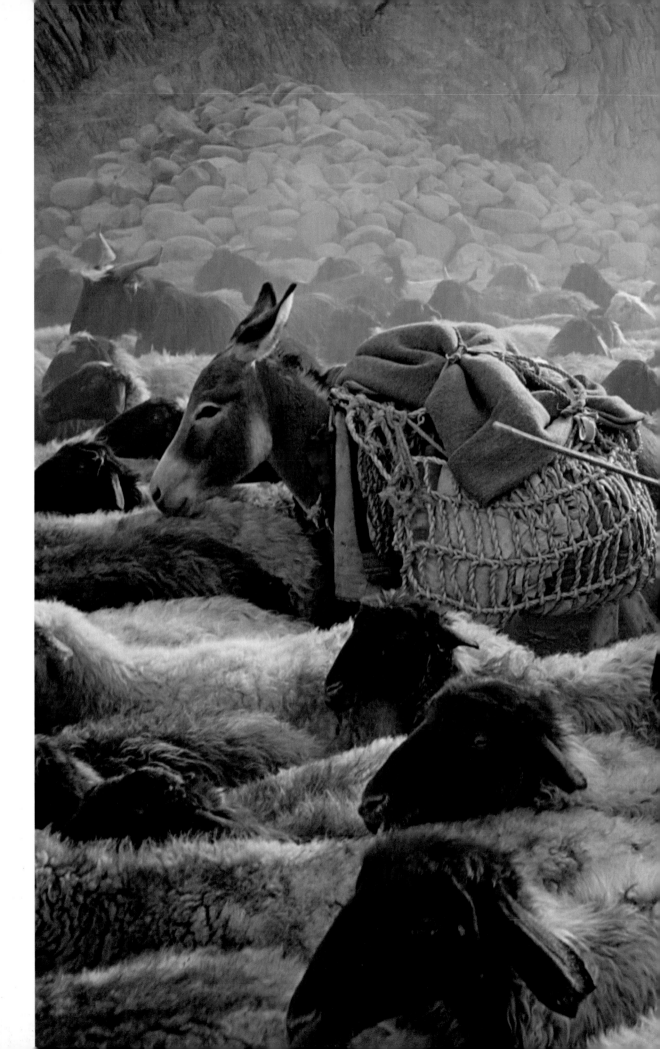

**KHOST, AFGHANISTAN.
AUGUST 5, 2002**
A man with his herd of
sheep on the road just
north of Khost, about
150 kilometers south of
Kabul, in Paktia
Province in eastern
Afghanistan.

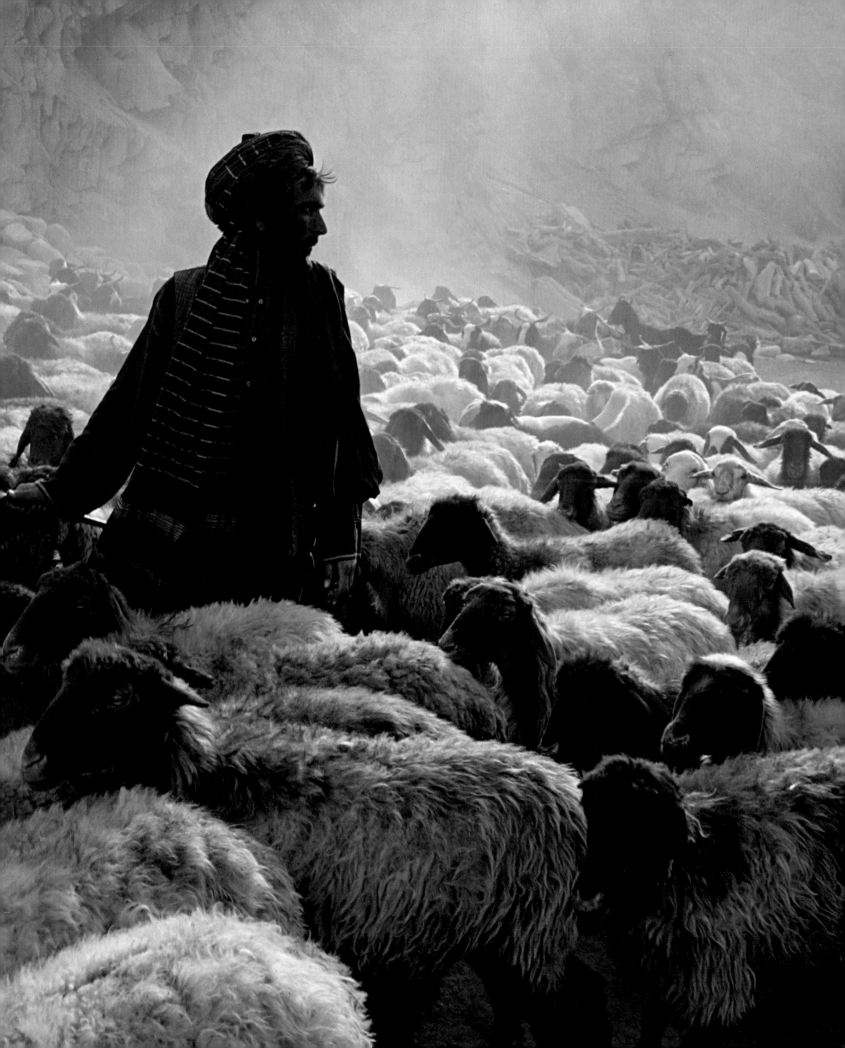

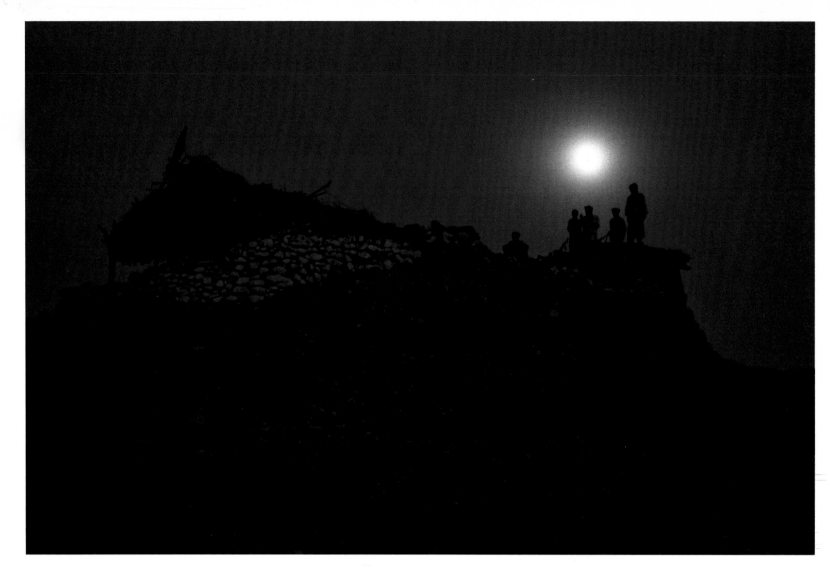

JALALABAD, AFGHANISTAN. AUGUST 23, 2002
As the moon rises outside of Jalalabad a group of Afghan soldiers
watch from their post above the road. Security on the roads is
bad at night, with robbery by bandits a common occurence.

SHEBERTOO, AFGHANISTAN. DECEMBER 5, 2001
Abdul Hussain, who had returned to his Shebertoo village once
the war ended, feared that his two-year old son would soon die.
As cold weather set in and food was in short supply, many
Hazara tribespeople living in Shebertoo faced a bleak and diffi-
cult winter.

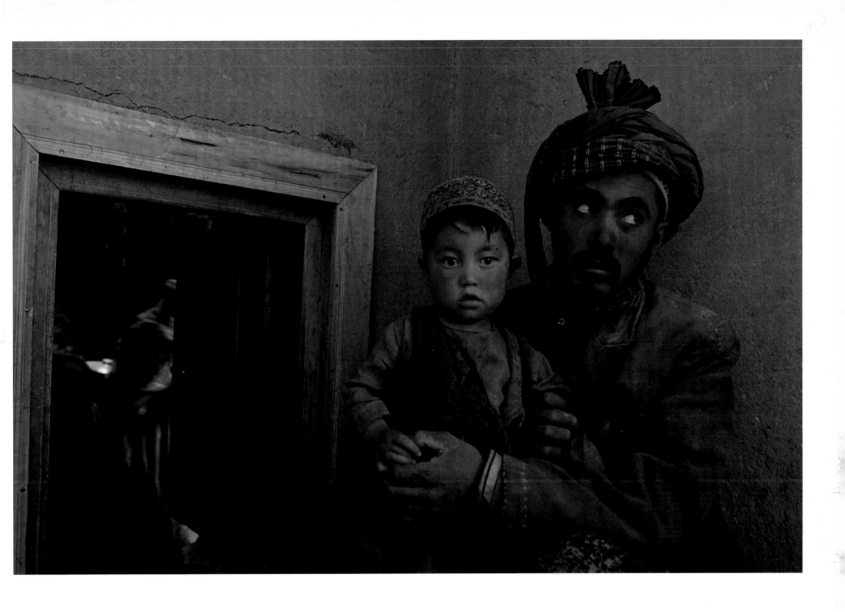

BAMIYAN, AFGHANISTAN. DECEMBER 5, 2001

Local Hazara women walk past the site where one of two Buddhist statues was destroyed by the Taliban in March, 2001. It took one week to destroy the millenia-old statues, using drills and airplane bombs. The Buddhas were carved out of sandstone here 1,500 years ago. Ethnic hatred motivated the Taliban to commit methodical killings of the Hazara tribes, causing many to flee. The Taliban then restricted entry to the region for three and a half years. Destitute Hazaras were finally able to return following the Taliban's retreat, only to find that the destruction had affected not only the Buddhist statues, but also their homes, many of which were completely destroyed.

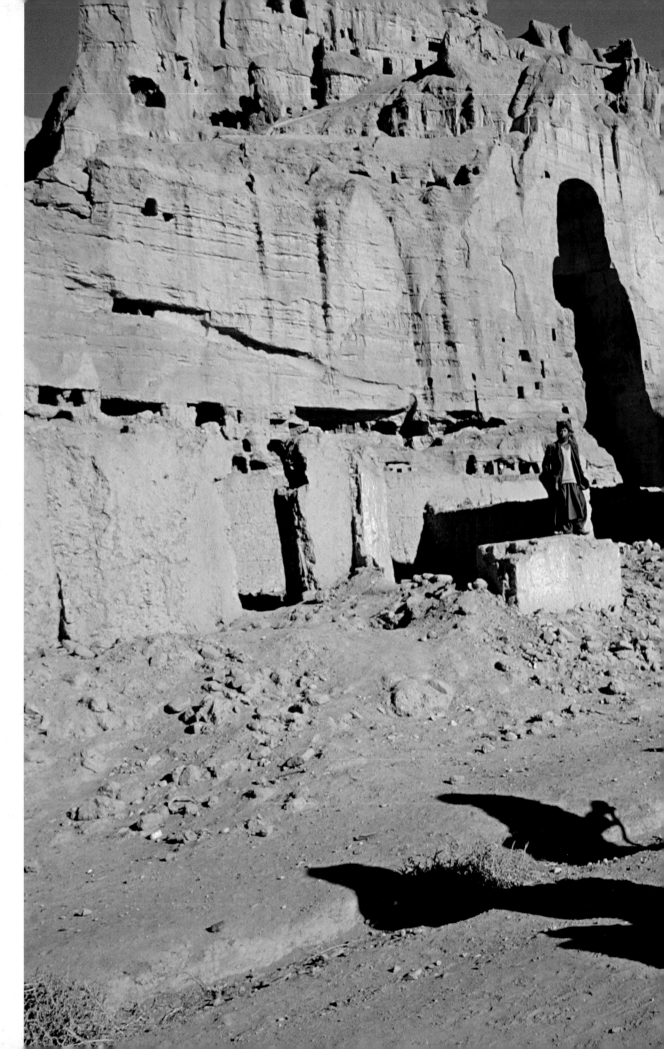

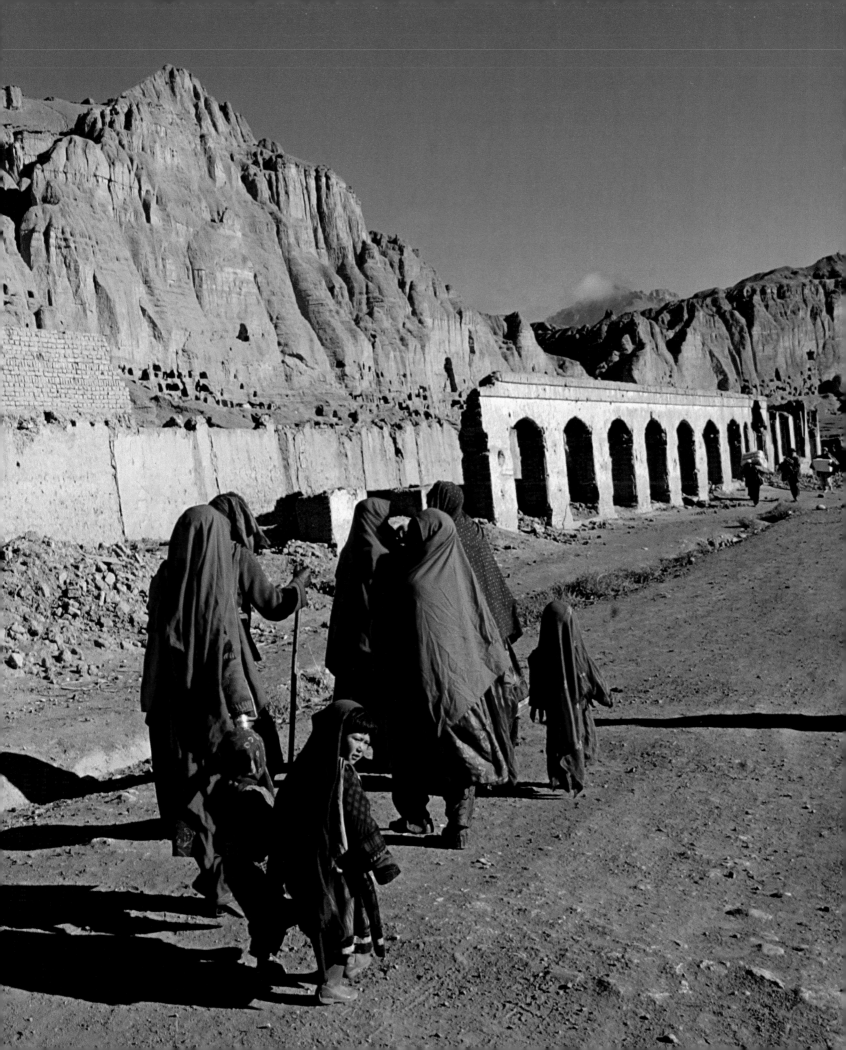

KABUL, AFGHANISTAN. AUGUST 12, 2002
Returning families pass through a barbed-wire fence at the UNHCR drop point for refugees. Hundreds of Afghans returned from Pakistan daily when peace was restored; more than 1.5 million returned in 2002. They are temporarily stopped here so UNHCR can count families and give them a briefing before they proceed. They also receive a small sum of money, blankets, and cooking oil before proceeding on their journey.

KABUL, AFGHANISTAN. AUGUST 18, 2002
A boy plays on a rope swing, which also serves as a cradle for his baby sister, in his home in Kabul, Afghanistan. He recently moved back to Afghanistan with his family from Pakistan, where they were living as refugees. They return to squat in a crumbling shell of a building. There is no electricity, no running water, and no sewage system here, opening the door to sickness and disease, especially among the young. Thousands who return to Afghanistan with no money or prospect for jobs find themselves having to make a living under such conditions, in neighborhoods so decimated by war that they are considered to be unsafe even by the poorest of Afghan standards.

PUL-I-CHARKI, AFGHANISTAN. AUGUST 13, 2002
Men feed wood into a high-temperature brick oven as they cook clay into bricks in Pul-i-Charki, just east of Kabul. This traditional method of making brick was thriving due to the need to reconstruct homes damaged or destroyed during the war.

KHANJAR KHIL, AFGHANISTAN. OCTOBER 30, 2001
Northern Alliance soldiers three miles from the front line park a T-62 Russian tank as villagers pass by on a bicycle. These tanks were often inadequately equipped, with little ammunition for battle.

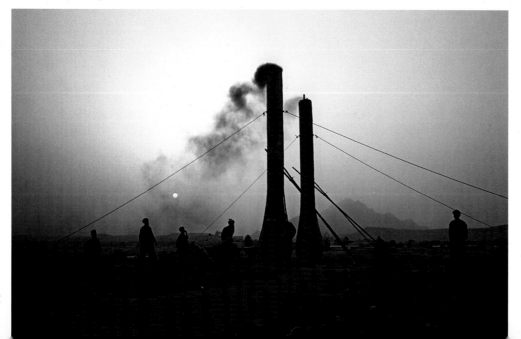

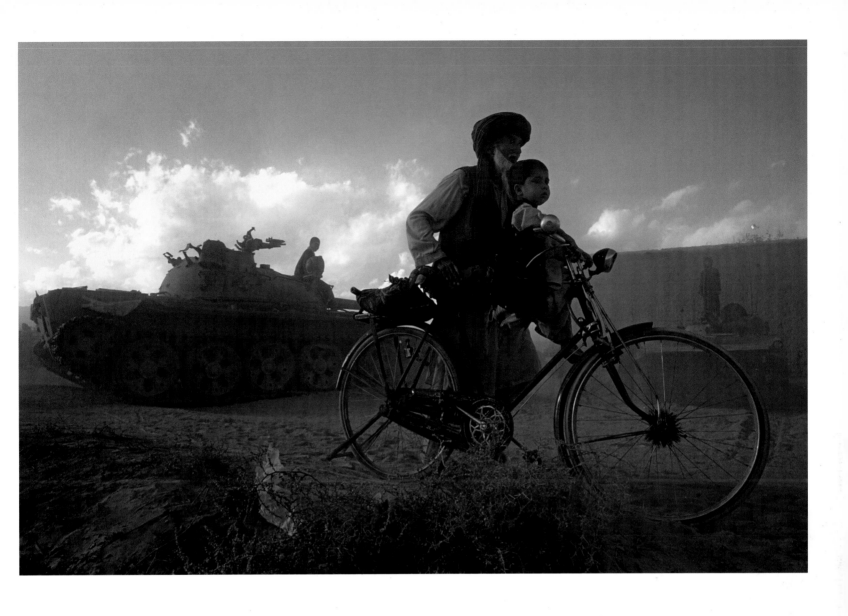

KABUL, AFGHANISTAN. AUGUST 8, 2002
Abdul Rahim, forty-two, heard that it was peaceful in Afghanistan and moved with his family from Iran, where he was a refugee with his wife and four children. They now live in a crumbling shell of a building, hoping to move on to their home village in Mazar-i-Sharif, although they have no money to make the trip.

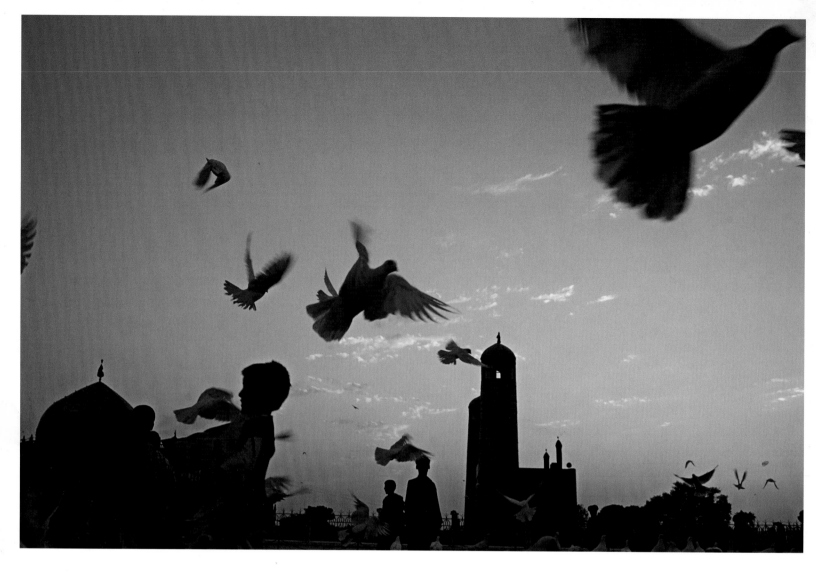

MAZAR-I-SHARIF, AFGHANISTAN. 2002.
Pigeons take flight in front of the Shrine of Hazrat Ali, the
sacred burial place of the son-in-law and cousin of Muhammad,
and founder of the Shiite sect of Islam.

GHAZNI, AFGHANISTAN. AUGUST 26, 2002
Despite death threats from the Taliban, about 2,500 Afghan girls
attended a school a year after they fled this village which was
captured in 1995. Lingering Taliban forces attacked the school,
bombing its yard and damaging a wall. Nobody was hurt, but
leaflets scattered threatened death to any women or girls who
returned to school. This school is one of thousands which
reopened since the lifting of the Taliban's ban on education for
girls. Although many Afghans praised the United States for liber-
ating them from the Taliban, others criticized them for failing to
provide adequate security, saying that all efforts had gone to the
hunt for Osama bin Laden and Al-Qaeda—thinning out resources
for the people who needed them.

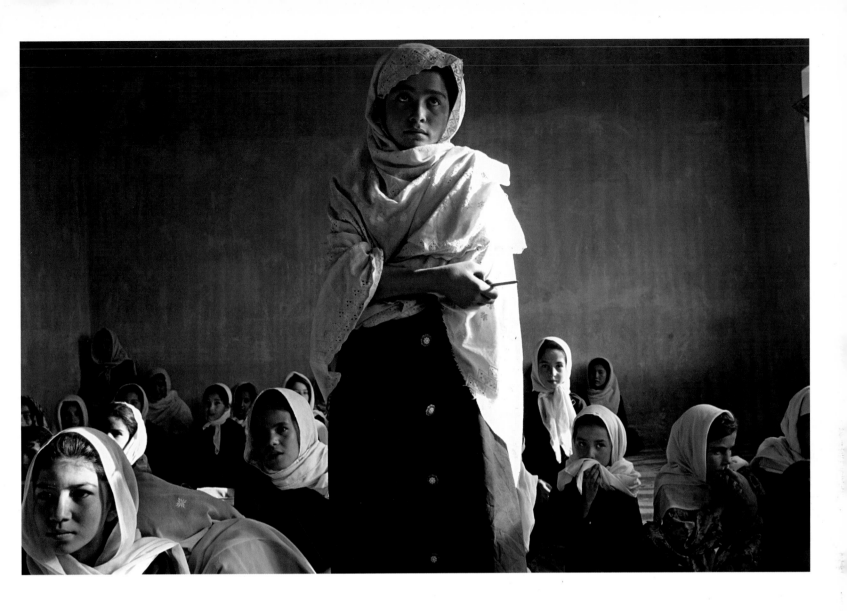

Life changed for Afghans after the war. While the strict Islamic law was lifted, the daily struggle of a country in upheaval continues.

KABUL, AFGHANISTAN.
AUGUST 18, 2002
The walls are marked with shell and bullet holes from years of war.

KABUL, AFGHANISTAN.
AUGUST 14, 2002
Early evening shopping in downtown Kabul.

KABUL, AFGHANISTAN.
NOVEMBER 20, 2001
An Indian movie in the Bakhter cinema. During Taliban control, movies were outlawed. Now the cinemas have reopened and the theaters are packed.

KABUL, AFGHANISTAN.
AUGUST 15, 2002
Blind women fill buckets of water for cleaning chores.

KABUL, AFGHANISTAN.
AUGUST 18, 2002
Smoking hashish in Afghanistan. Both hash and opium are major drug exports in Afghanistan.

KABUL, AFGHANISTAN.
SEPTEMBER 13, 2002
An Afghan woman prepares for her wedding at a beauty salon, where burqa culture is giving way to a revival of feminine pursuit of beauty.

KABUL, AFGHANISTAN.
SEPTEMBER 13, 2002
An Afghan nomad boy. The wandering nomad communities suffer greatly from landmine accidents.

KABUL, AFGHANISTAN.
OCTOBER 2, 2002
The currency exchange market in Kabul.

(Continued)

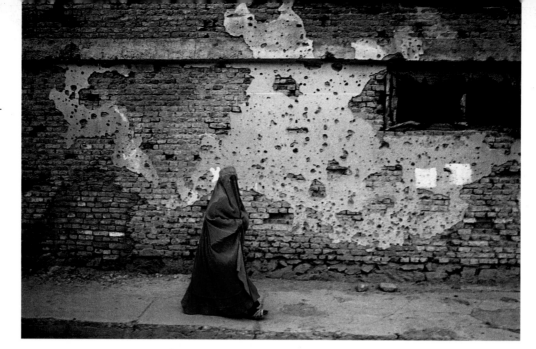

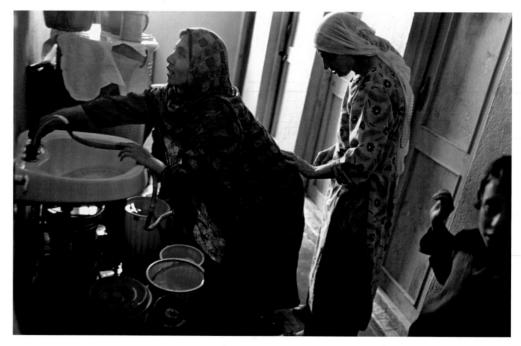

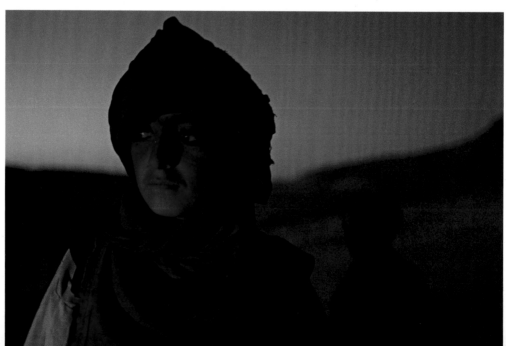

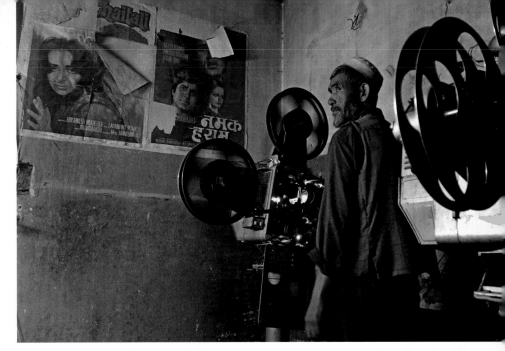

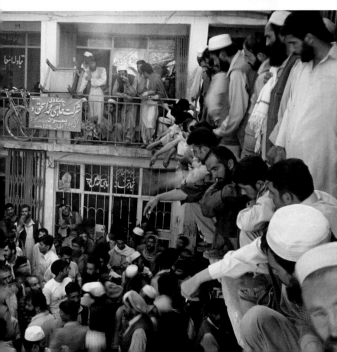
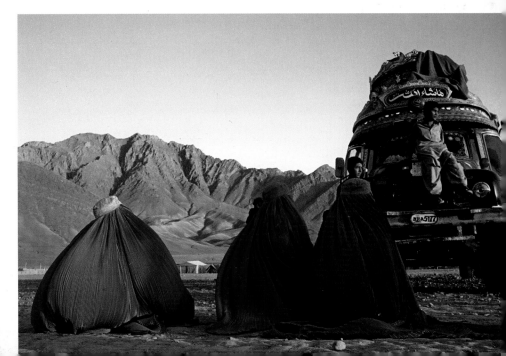

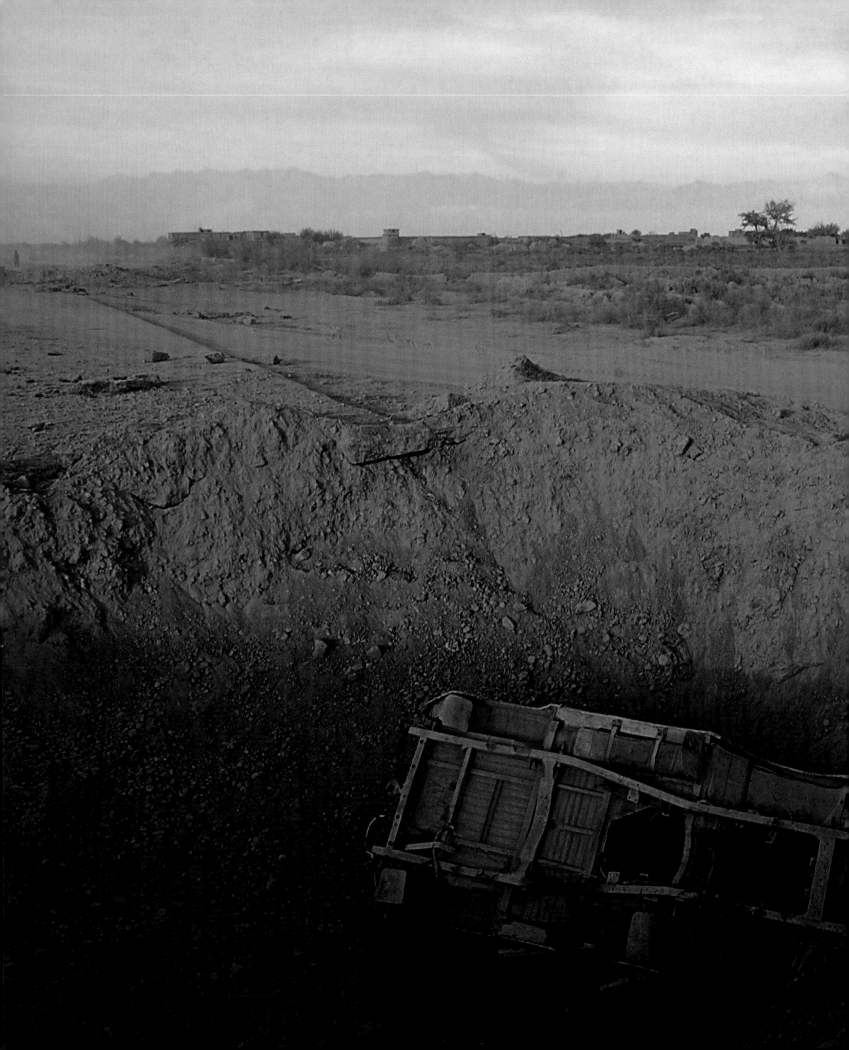

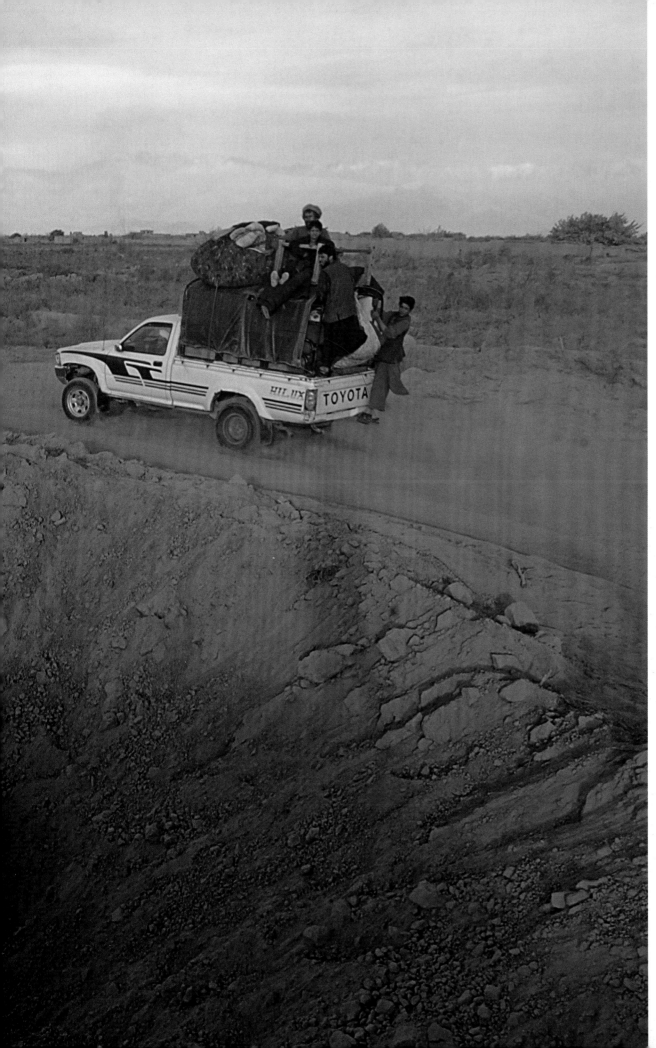

**KABUL, AFGHANISTAN.
NOVEMBER 18, 2001**
A family of returning Pakistani refugees drive past a crater left by B-52 bombing on the old Kabul road north of the city. The road, which was under Taliban control a week before, was bombed in anticipation of the Northern Alliance advance. Air strikes would then shift to possible Taliban hide-outs along the Tora Bora mountain range near the boarder with Pakistan.

Previous pages:
**PUL-I-CHARKY,
AFGHANISTAN.
OCTOBER 2, 2002**
An Afghan refugee family, who arrived at a UNHCR processing point in Pul-i-Charky, Afghanistan, following their journey from Peshawar, Pakistan. Many Afghans have been cheating the UNHCR, who pays Afghan returnees $20 per family member on their return to the country. The refugee families taking advantage of this move back and forth into Afghanistan, collecting their payment every time, sometimes altering their appearance to pass unnoticed. Some families have made the trip dozens of times at a profit of thousands of dollars. This family had not yet received their payment so were unable to pay the driver of the truck who had transported them. Iris scanning technology was later being used at the border to identify those Afghans returning here.

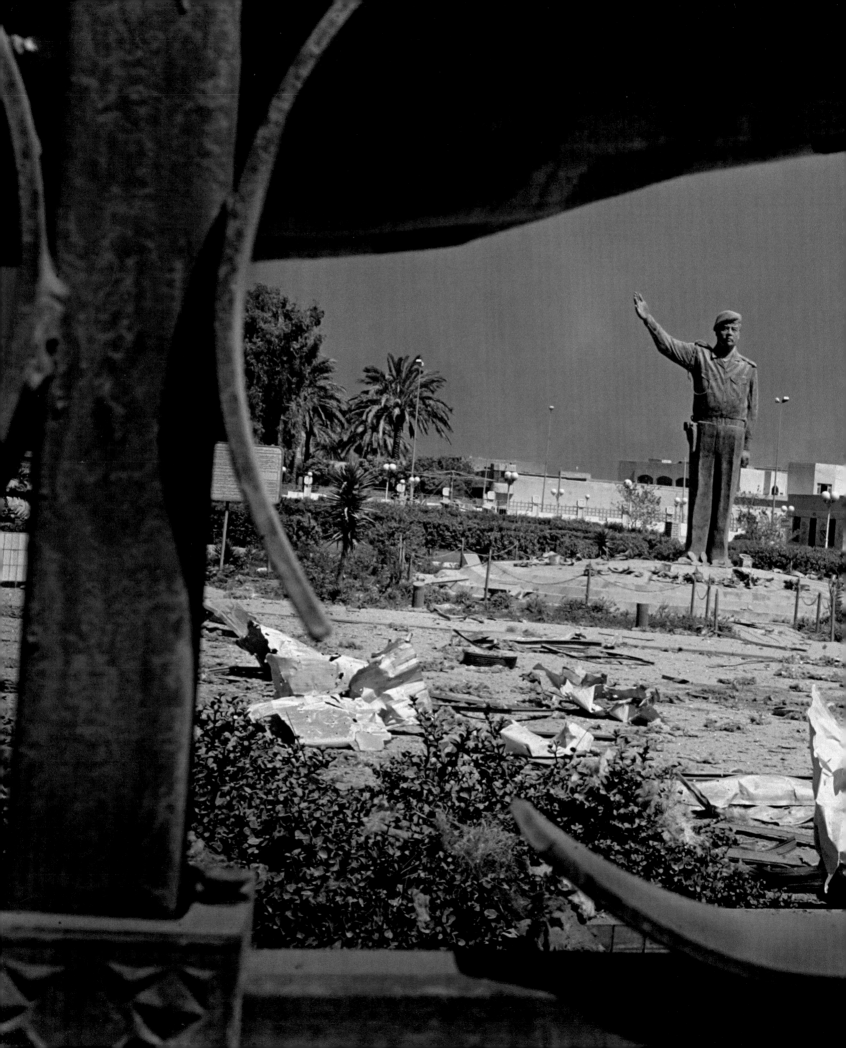

BAGHDAD, IRAQ. MARCH 28, 2003
A statue of Saddam Hussein among the rubble of Saddam Tower, a major communications center serving Baghdad, bombed by the Americans. The heavy bombing campaign in Baghdad targeted palace complexes, government buildings, and communications facilities. Before the war Saddam Hussein took the precaution of ordering the construction of duplicate communications systems as well as hidden, underground cables. A more elaborate network surrounded the President personally, always offering an escape route in the case of trouble. Dictatorship came with a price; but, being a skilled survivor, Saddam never left a stone unturned. His inner circle was closely monitored and there was little opportunity for outside influences to harm him. Saddam even had his own dental office and dentist inside a palace so that no foul play could be carried out by an enemy doctor.

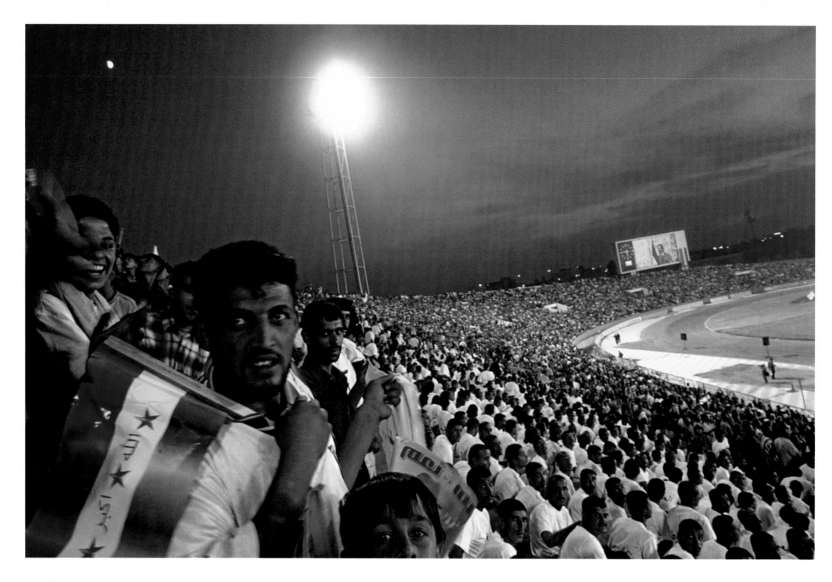

BAGHDAD, IRAQ. OCTOBER 14, 2002

Iraqi men pack a stadium in Baghdad to show their support of
Saddam Hussein at a rally on the eve of a referendum. The
rally, attended by about thirty-thousand people, was a curtain-
raiser to a soccer game, played between two popular Baghdad
teams. Many in the crowd wore t-shirts bearing Saddam's face,
others patriotically waved Iraqi flags and cheered in support of
their President as fireworks lit the sky overhead and parachutists
descended from above. Banners were displayed with the theme:
"Saddam is Iraq! Iraq is Saddam!" Such display was an expect-
ed, if not mandatory, fact of life in Iraq. From grade school,
Iraqi children were greeted by pictures of Saddam in their text-
books. Speaking out against Saddam would land someone in
Abu Ghraib prison, or would be punishable by execution. Even
voting for president in Iraq consisted of a card with only two
options: Saddam Hussein, Yes or No. The referendum was a
success, with Saddam winning exactly one-hundred percent of
the vote.

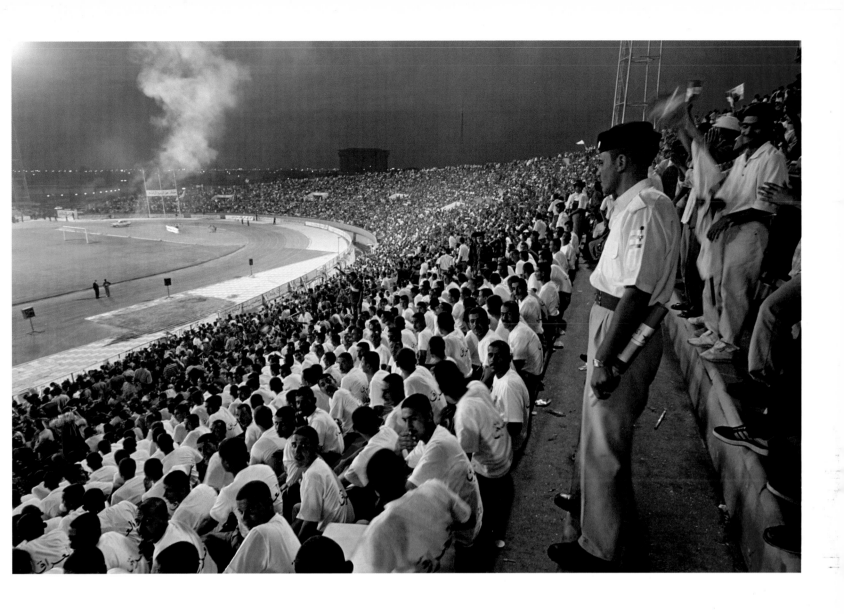

**BAGHDAD, IRAQ.
OCTOBER 14, 2002**
Stadium rally for
Saddam.

Following pages:
Throughout his lengthy
term as President of
Iraq, the iconic image of
Saddam Hussein was
present almost every-
where; on buildings,
murals, statues, watch-
es. After the collapse of
his regime, rare photo-
graphs of the former
President began to sur-
face. Old black and
white photographs show
Saddam as a student at
Baghdad University, his
birthplace at Owja, a
Ba'ath party typewriter,
the bullet-ridden car in
Saddam's attempt to
assassinate the previous
President of Iraq, and
photographs of the Umm
Al-Mahare (Mother of All
Battles) mosque where
the Koran was written in
Saddam's own blood.

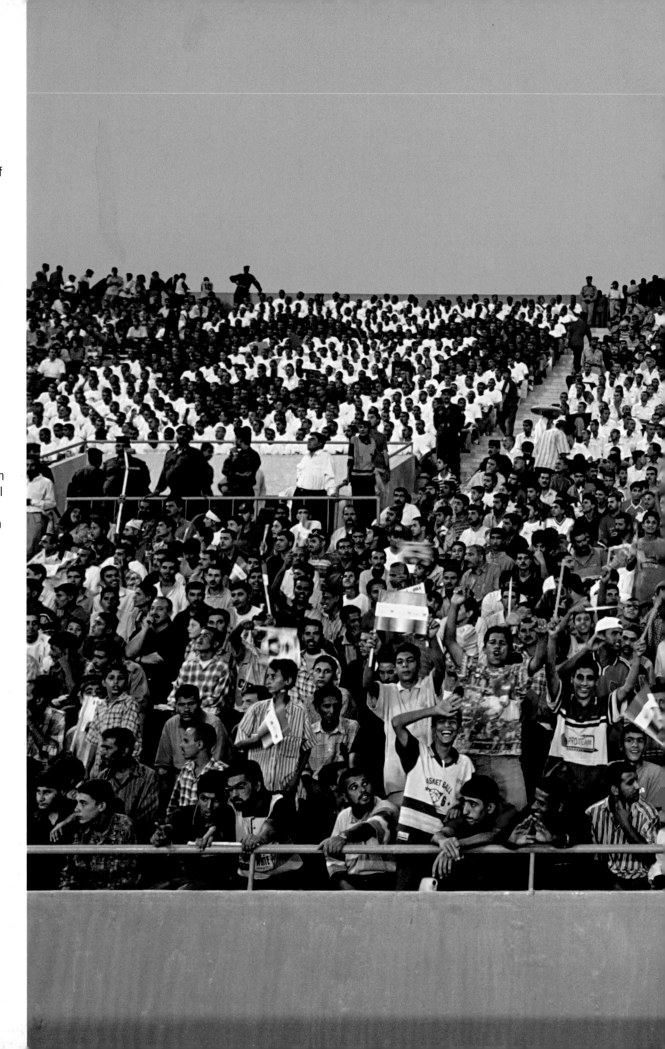

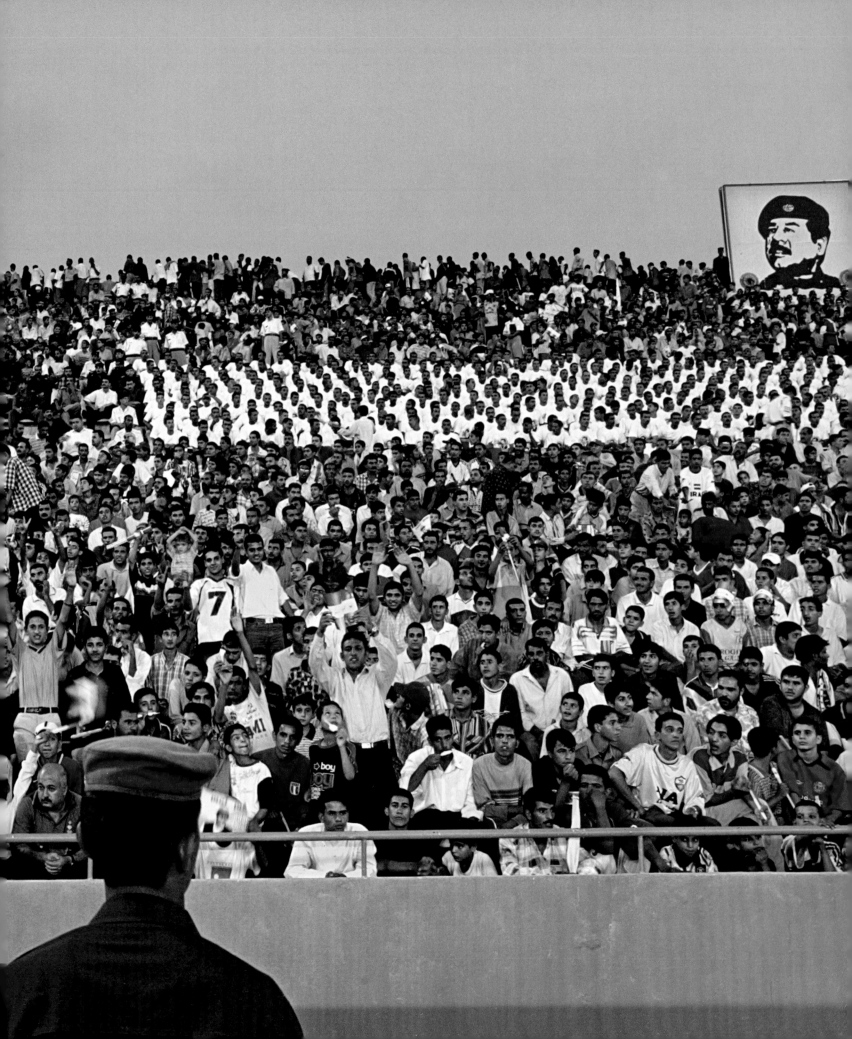

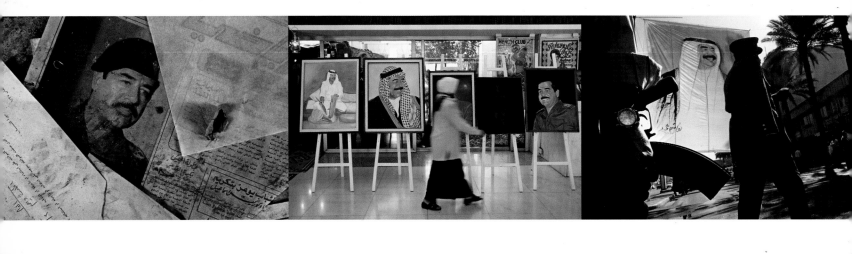

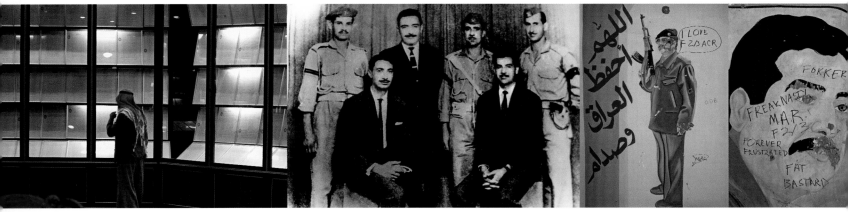

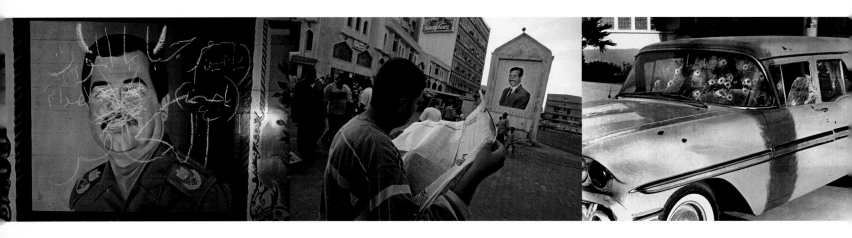

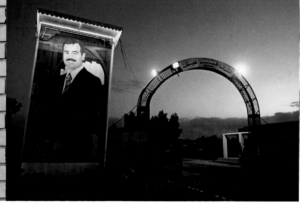

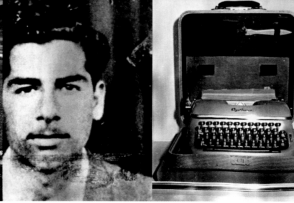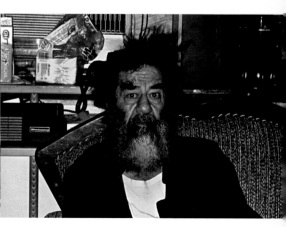

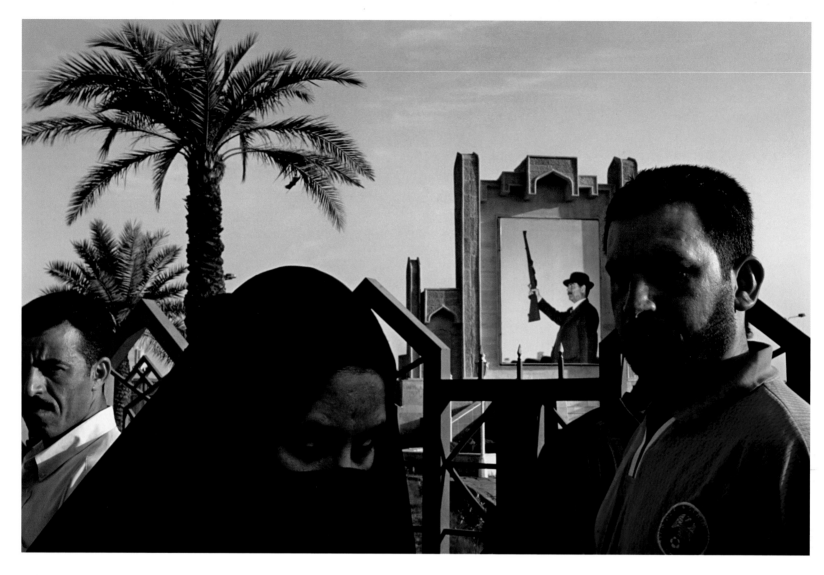

BAGHDAD, IRAQ. OCTOBER 14, 2002

The ubiquitous image of Saddam in Iraq could be imposing: for the people living there it was symbolic of the all-seeing eye of their President. Virtually everything portrayed him in a never-ending display of strengths and attributes. Billboards, backlit displays hung inside restaurants, images painted on watch faces, stickers, paintings, endless statues, and monuments were all iterations of his egomaniacal rule. These icons of Saddam would soon be burned, toppled, and defaced by a nation who lived in fear of his omnipresence for twenty-three years.

QAIM, IRAQ. DECEMBER 10, 2002

Iraqi guards watch from the roadside as a team of nuclear inspectors drives past on their way to a uranium mine near the Syrian boarder, which in the 1980s and 1990s produced "yellowcake" uranium dioxide that Iraq had attempted to enrich for nuclear weapons. Saddam Hussein became confrontational at this stage of inspections, fueling a heated debate with the United States over a 12,000-page arms declaration.

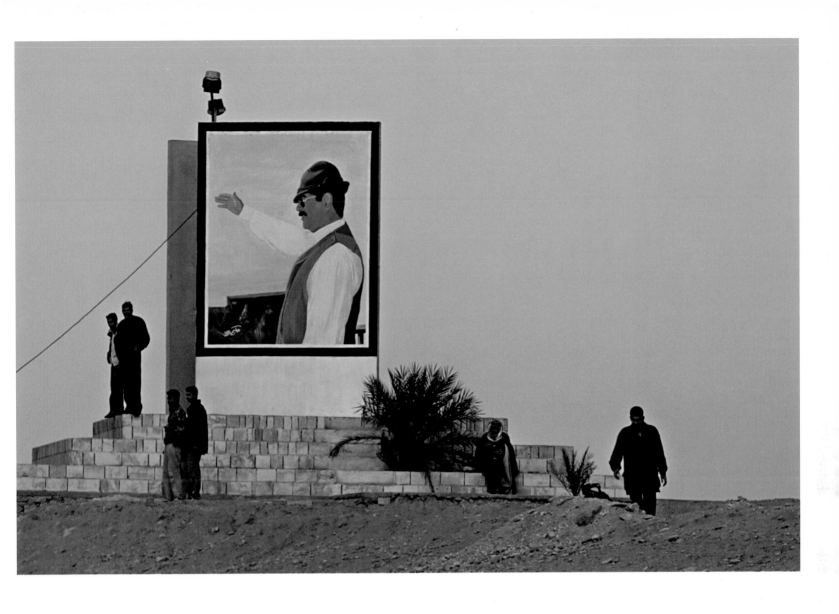

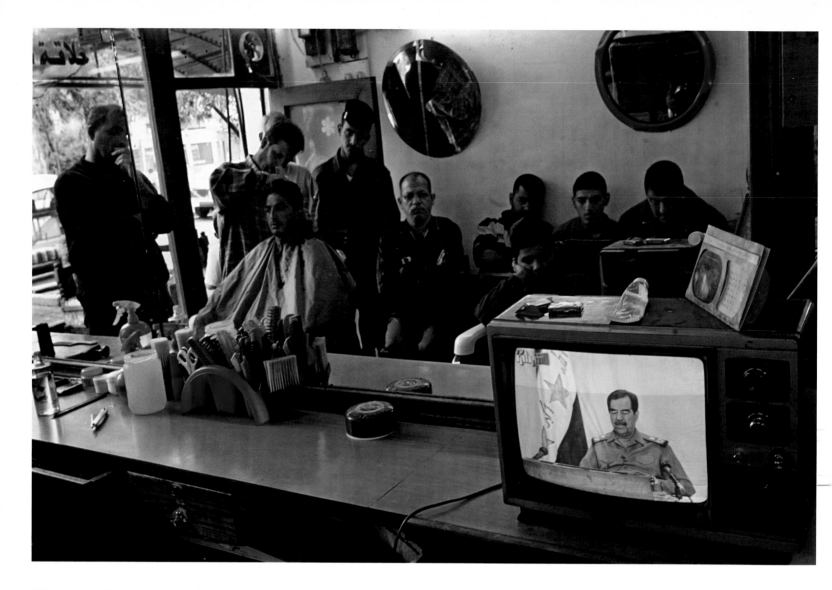

"The lesson that you are teaching our enemies will make them incapable of challenging you or humanity again. Hit them hard. Hit them hard to the point that evil will be defeated, and all mothers, fathers and children that have been terrorized by the aggression will be able to sleep in peace, and your deeds and your jihad will send them back in disappointment and despair...."

—Saddam Hussein, in a televised speech to the nation, Baghdad, Iraq. March 24, 2003

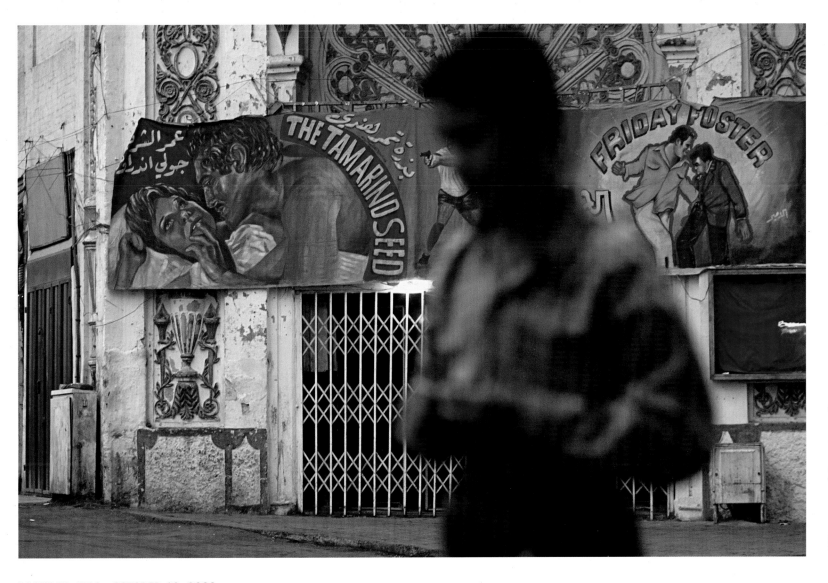

BAGHDAD, IRAQ. OCTOBER 16, 2002
An Iraqi man walks past a movie theater on Rashid Street, the oldest street in Baghdad which during the time of the regime was popular for its shops and tea cafés, often filled with men smoking nargila pipes and playing dominoes. Following the coalition-led invasion of Baghdad, virtually every business on this street was looted and burned, leaving it a destitute haven for the city's worst criminals. The coalition was heavily criticized for not providing adequate security when they entered Iraq, allowing looters to destroy many of Baghdad's neighborhoods.

Opposite:
BAGHDAD, IRAQ. MARCH 24, 2003
Saddam Hussein speaks from hiding to the people of Iraq, urging resistance to the American-led invasion.

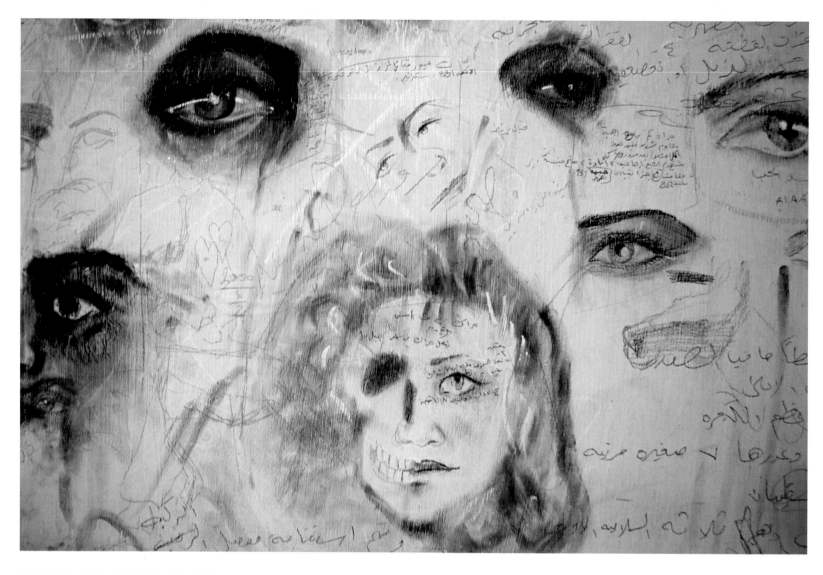

BAGHDAD, IRAQ. OCTOBER 10, 2002
A drawing made with charcoal by an Iraqi student on the wall of
an art school in Baghdad, Iraq.

BAGHDAD, IRAQ. DECEMBER 5, 2002
Iraqis enjoy the first evening of the festival of Eid Al-Fitr, ending
the Muslim holy month of Ramadan, at a park in central
Baghdad, where families gather to enjoy sweets and take photo-
graphs. At the same time, Saddam Hussein breaks his silence
on the new United Nations weapons inspections, urging his asso-
ciates in the Iraqi leadership to have patience in the face of
American pressures. Referring to the threat of an American mili-
tary attack if the inspections turned up anything, he said Iraq
should let the inspectors do their work so as to "keep our people
out of harm's way."

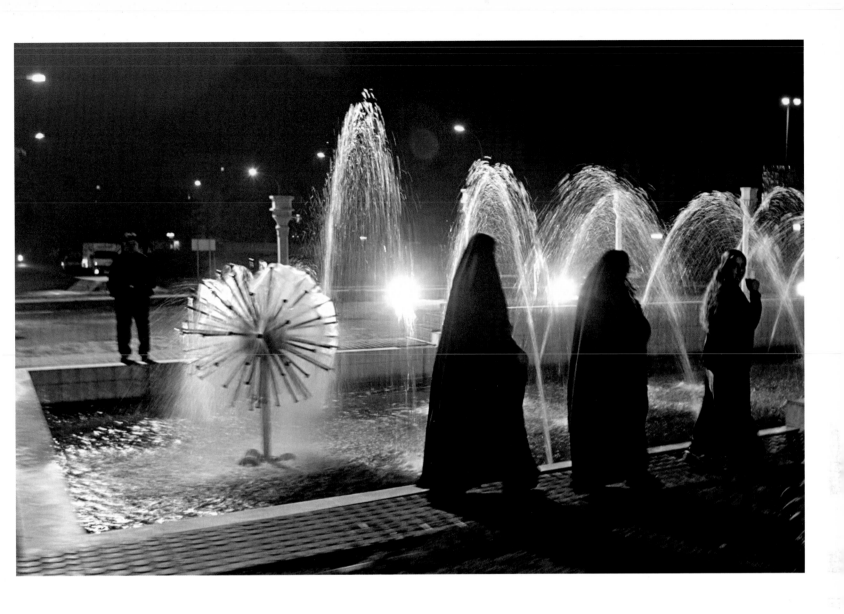

BAGHDAD, IRAQ. MAY 7, 2003
An elderly Iraqi woman sleeps on the floor of a room inside the
Ministry of Defense in Baghdad. Several families uprooted from
the war moved in with their own furniture and supplies and were
squatting in this former government building without running
water. Mobs of others moved into high-end apartments along the
Tigris River which were formally reserved for Saddam's Special
Republican Guard and their families who fled before the inva-
sion.

BAGHDAD, IRAQ. MAY 7, 2003
An Iraqi woman is reflected in a mirror as she drinks water in her
makeshift kitchen inside the Ministry of Defense in Baghdad.

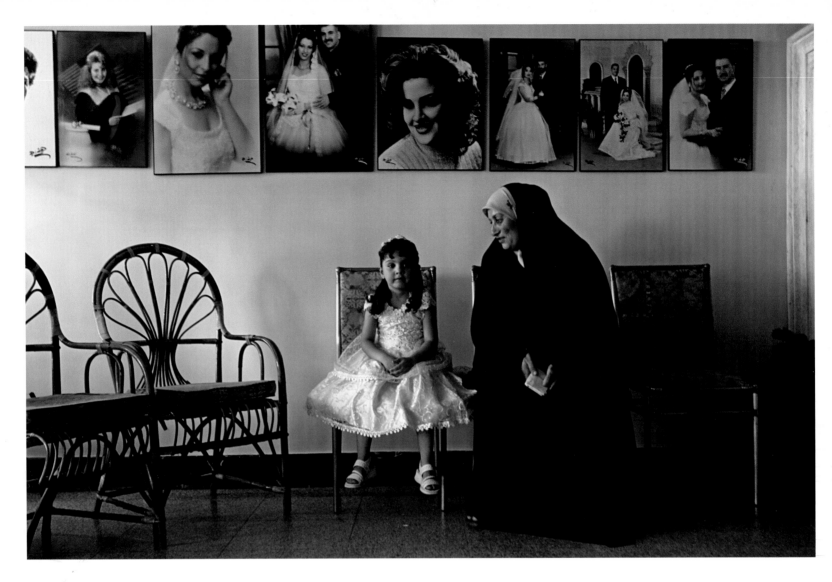

BAGHDAD, IRAQ. JULY 17, 2003
Hijran Wajdi, six, waits with her grandmother, Sabiha Suhail, to
have her birthday portrait made at Haithem and Zuhair Photo
Studio. Following a day of violence in Iraq, Baghdad enjoyed a
day of quiet, a day which marks the thirty-fifth anniversary since
the Ba'ath Party came to power, paving the way for Saddam
Hussein's regime. Some shops closed, and the streets were
quiet in the city on a day which is normally a national holiday.
Iraq's new governing council has outlawed any celebration of the
1968 coup.

BAGHDAD, IRAQ. MARCH 14, 2003
Just days before bombs began to drop on Baghdad, officially cat-
apulting the country into war, Iraqi horse jockeys line up for a
cheering crowd of about 5,000 as they prepare to race at Al
Amiriya track, located in a suburb of Baghdad. "War or no war,
Americans or no Americans, I'll still be here with the horses,"
one jockey said. The horse races took place three times a week
at this track, which opened in 1995 (a former inner-city track
dating back to 1920, was bulldozed to make way for a new
mosque). Uday Saddam Hussein, one of Saddam's sons, was
the Jockey Club President and founding patron. His prized col-
lection of show horses was looted by a mob of Iraqis the day the
Americans arrived in Baghdad.

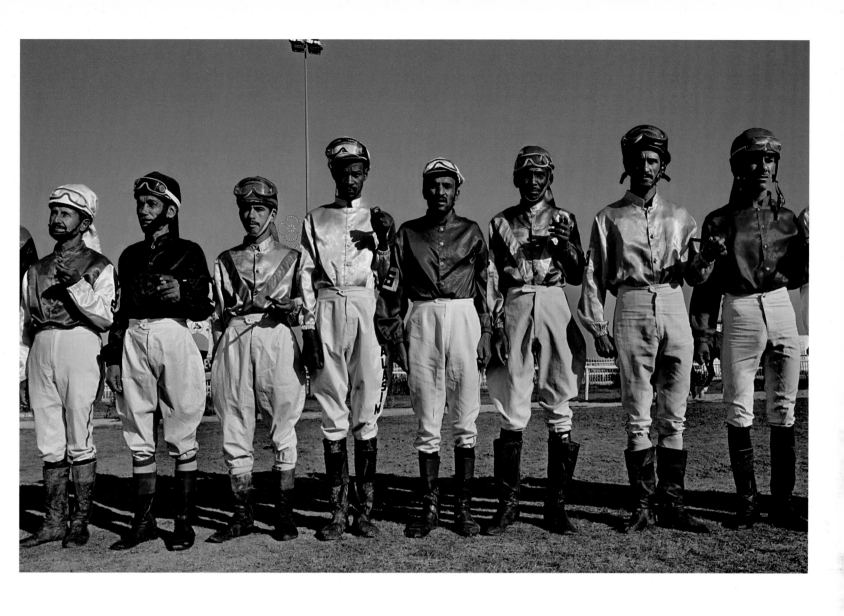

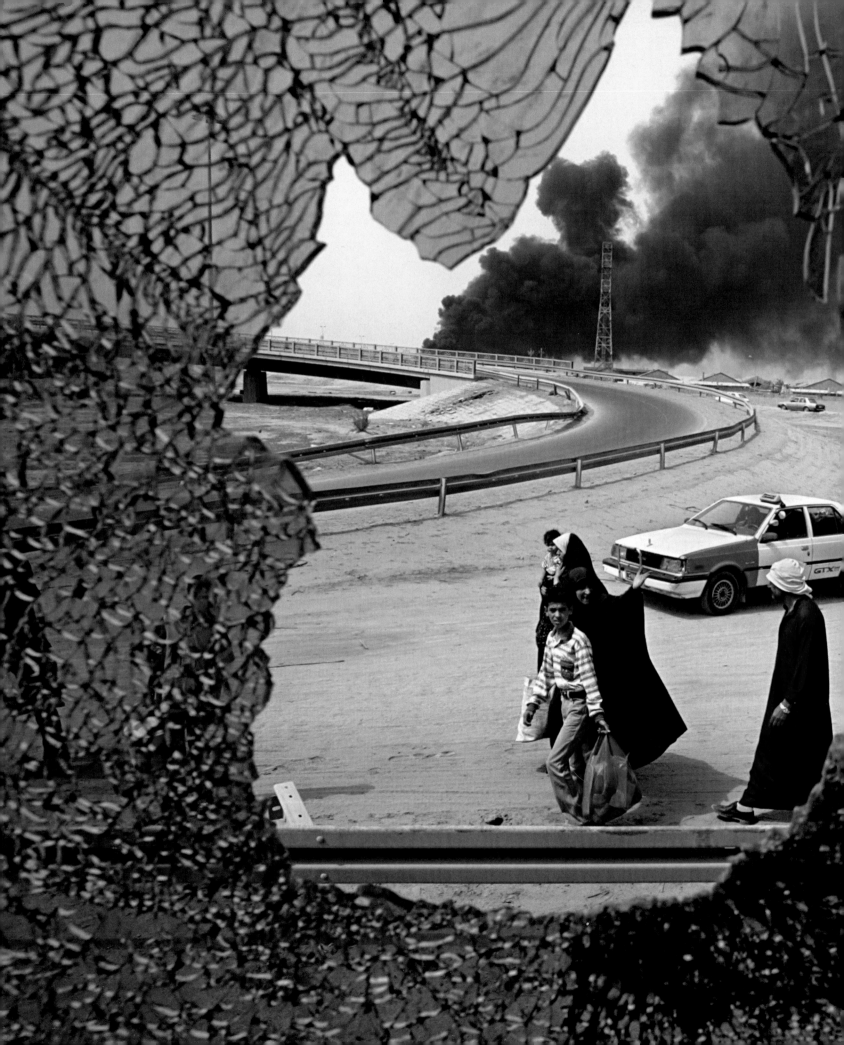

BAGHDAD, IRAQ. APRIL 6, 2003
Iraqi civilians pass a shattered
bus window as they flee the
area where an American tank
was engaged in fighting with
Iraqi soldiers on the highway in
Doura, a southern suburb of
Baghdad. About sixty tanks had
advanced with the Third Infantry
Division from the direction of
Baghdad Airport, entering a two-
hour firefight.

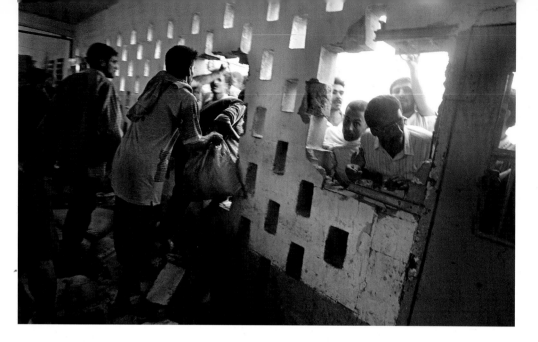

ABU GHRAIB, IRAQ. OCTOBER 20, 2002

Iraqi prisoners rush out of a crowded prison cell as tens of thousands of Iraqi prisoners are freed from the country's most notorious prison at Abu Ghraib, twenty miles west of Baghdad, after Saddam Hussein declared an amnesty treaty and emptied most of the country's prisons. The government gave no figure for the number released but human rights groups have estimated that Iraqi prisons held tens of thousands of political prisoners alone in addition to the thousands of others held for criminal offenses.

Chaos erupted throughout the vast prison compound after thousands of relatives broke through the main gates and raced to at least a dozen prison buildings, trying to spot imprisoned family members while they were still attempting to break out of the breeze-block holding compounds.

An Iraqi prisoner lays dead after being crushed in the crowds of prisoners exiting the dreaded prison. Dozens died in the frenzy to get out.

Iraqi prisoners are beaten by Iraqi soldiers as they attempt to exit their cells.

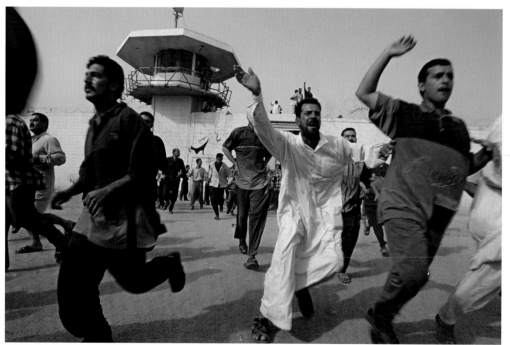

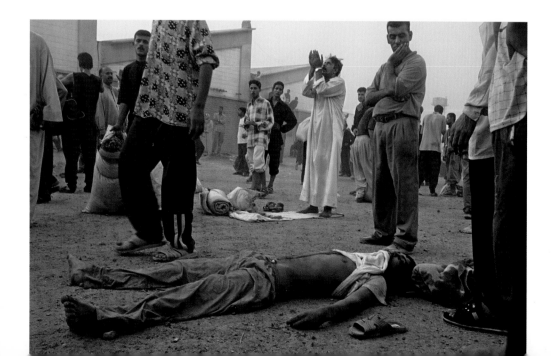

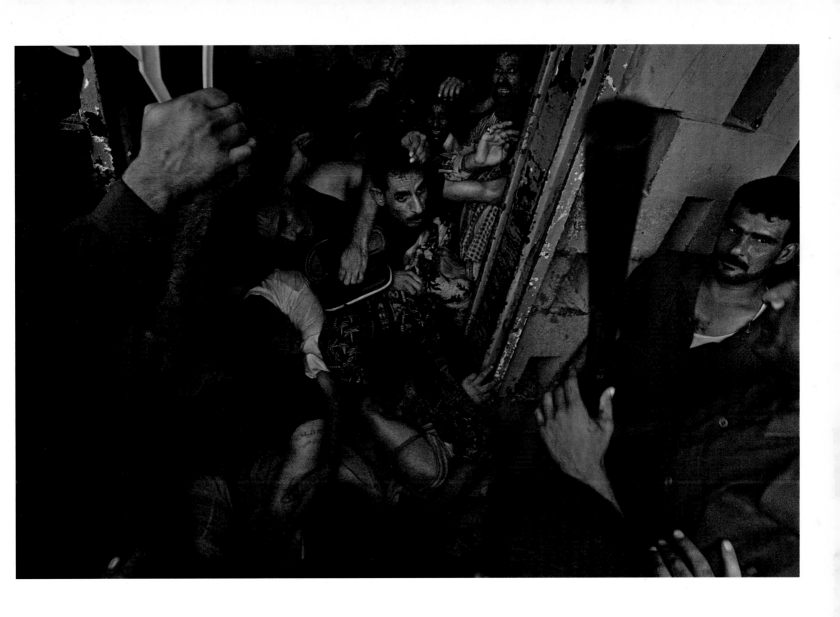

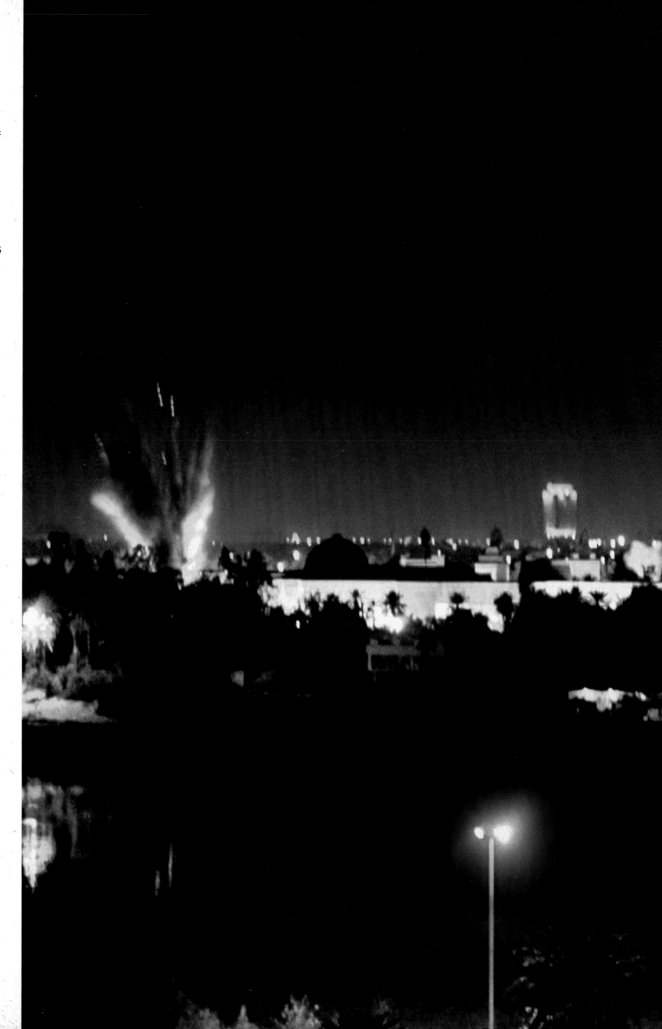

**BAGHDAD, IRAQ.
MARCH 21, 2003**
American Tomahawk missiles, fired from aircraft carriers, explode during the third evening of air attacks in Iraq in the grounds of Palace of the Republic, which consists of the main Palace complex, residences, and offices. This vast compound, which encompasses the Green Zone and serve as an American Army base, was one of more than twenty palaces the Iraqi President Saddam Hussein had for his personal use in Baghdad.

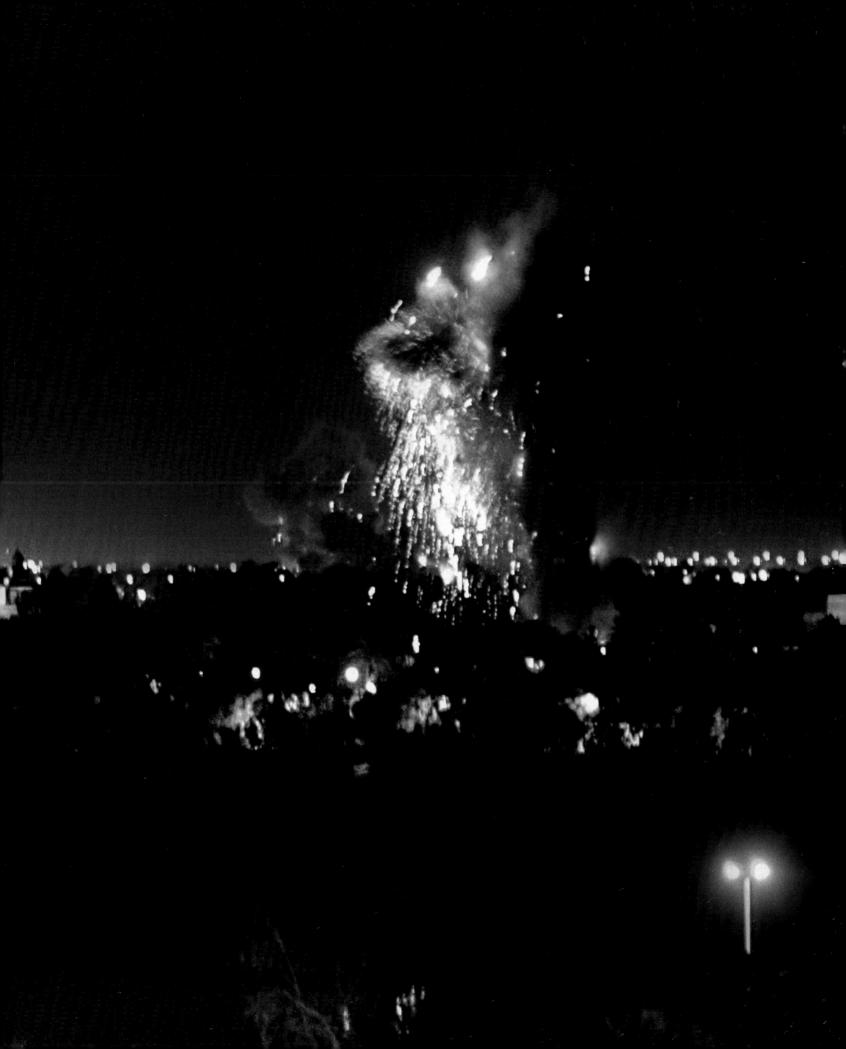

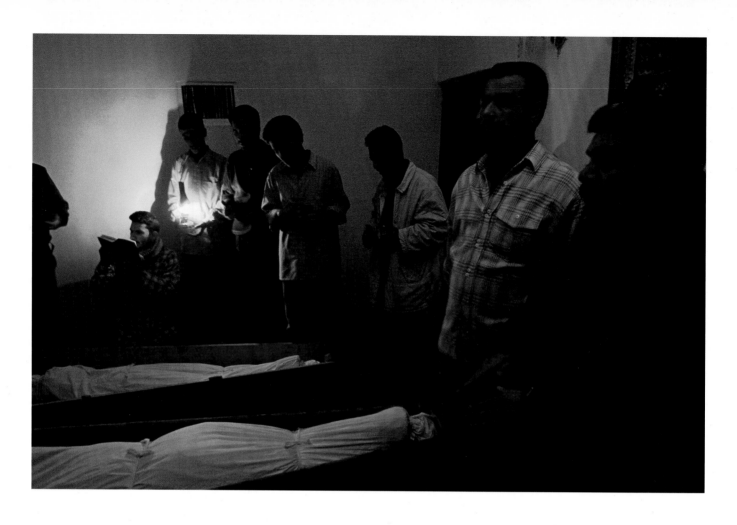

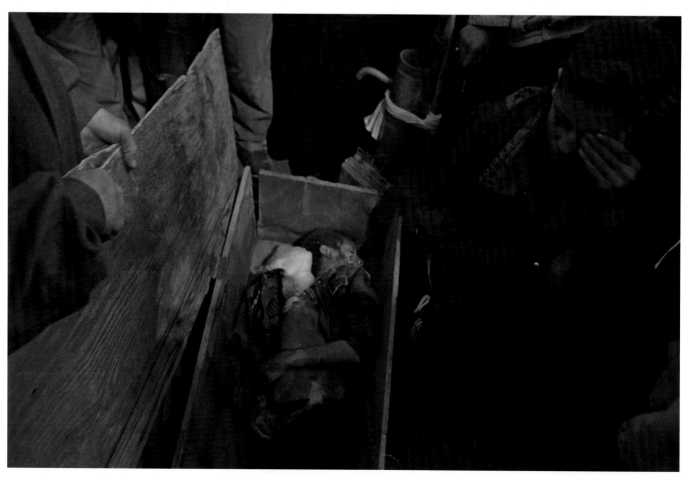

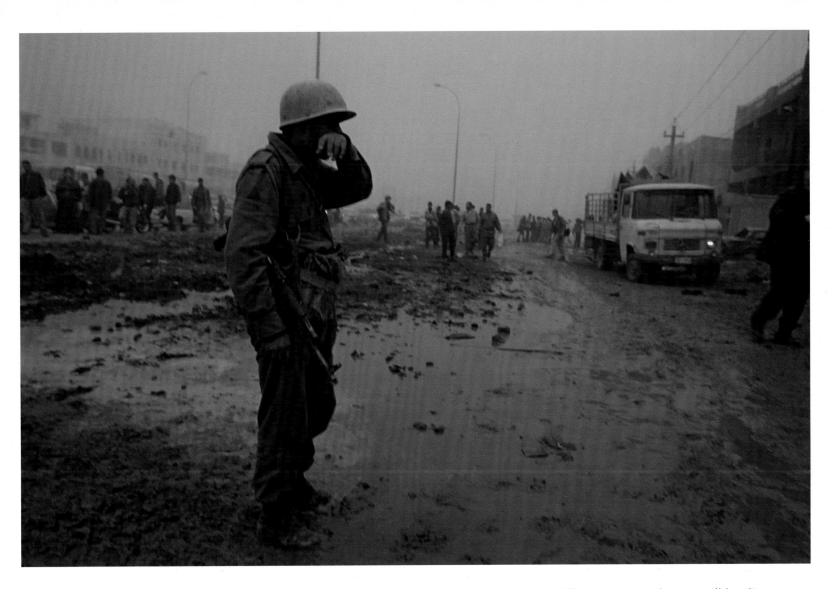

BAGHDAD, IRAQ. MARCH 26, 2003
Iraqi Army soldiers in a sand storm which darkened the daytime
sky at the scene where at least seventeen were killed and forty-
five injured when two bombs struck a strip of workshops and
apartments flanking both sides of a major highway running north
of Baghdad towards the city of Mosul. Errant missiles would
sometimes miss their intended target, or be thrown off their orig-
inal course due to scrambling by the Iraqis. This would send the
missile careening blindly into the city, often with devastating
results. In seconds an otherwise quiet neighborhood was thrown
into chaos and carnage. As customary in Muslim culture, the
dead are quickly buried the same day.

BAGHDAD, IRAQ. MARCH 28, 2003
Relatives mourn over a dead child inside a neighborhood mosque
as they prepare for burial in the Shula District of Baghdad, about
150 yards from a marketplace where an explosion took place at
5:30 pm. Estimates of the dead were as high as fifty-five,
depending on the Iraqi officials who gave them. The number of
wounded was also not known, but appeared to have been in the
dozens. Witnesses reported seeing a plane shortly before the
incident. According to Dr. Hassan Razouki, the Director of Al
Noor Hospital, "The local market... was crowded with lots of
people, including many children and many elderly, who went
there to buy food. The bodies were shattered by the missile,

which was intended to kill as many people as possible. It was
daylight. It was clear to anybody that the market was crowded,
and there are no military or strategic facilities in this area."

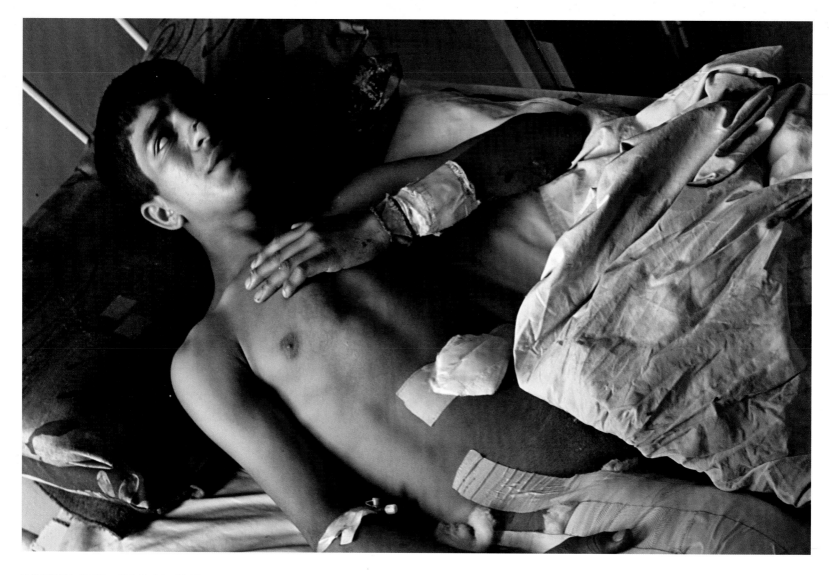

BAGHDAD, IRAQ. APRIL 14, 2003
An Iraqi boy who lost both his legs in a bomb strike lay in Al Sadr Hospital in Saddam City, a poor neighborhood in eastern Baghdad that is home to about two million people. One of the many casualties of the war, the innocent are often those who suffer most. Saddam City was later renamed Sadr City, which has evolved into Baghdad's epicenter of anti-coalition insurgency.

BAGHDAD, IRAQ. MARCH 26, 2003
Amera Abdalstra sits inside her damaged home, where she narrowly escaped death when another house next door to her was completely demolished in the Radiha Khaton neighborhood of Baghdad. Five Iraqis were killed and twenty-seven injured when a bomb dropped by American aircraft struck homes in the area.

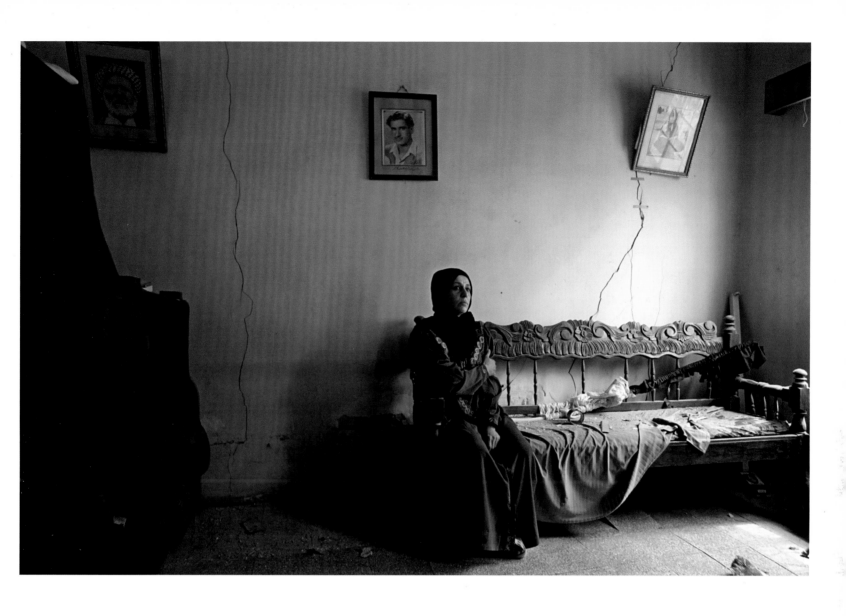

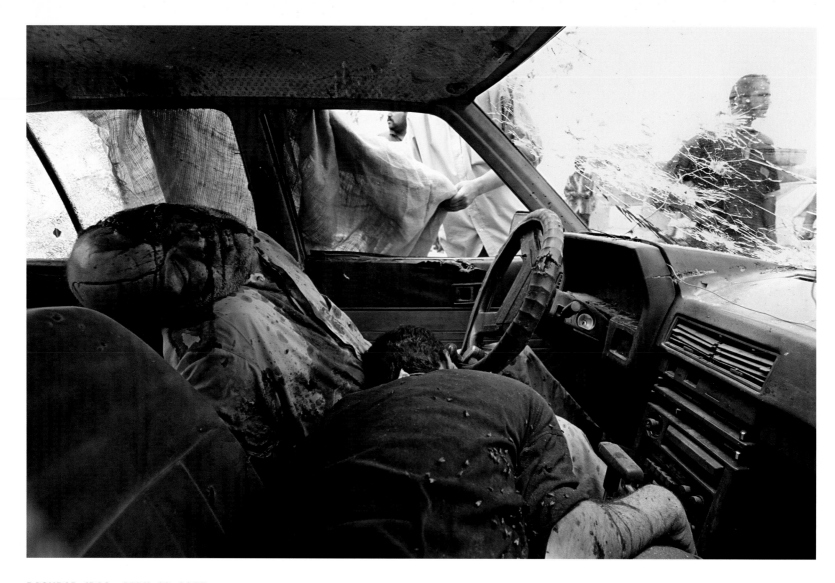

BAGHDAD, IRAQ. APRIL 10, 2003
A car where three Iraqi men were shot to death by American
Marines. The Marines had ordered the car to stop, and when it
failed to do so they opened fire, killing a father, his teenage son,
and another male relative who was in the passenger seat. A rela-
tive of the killed men towed the bullet-ridden car, with the three
bodies still inside, to their family home where the women of the
house, waiting for news of their whereabouts, mourned.

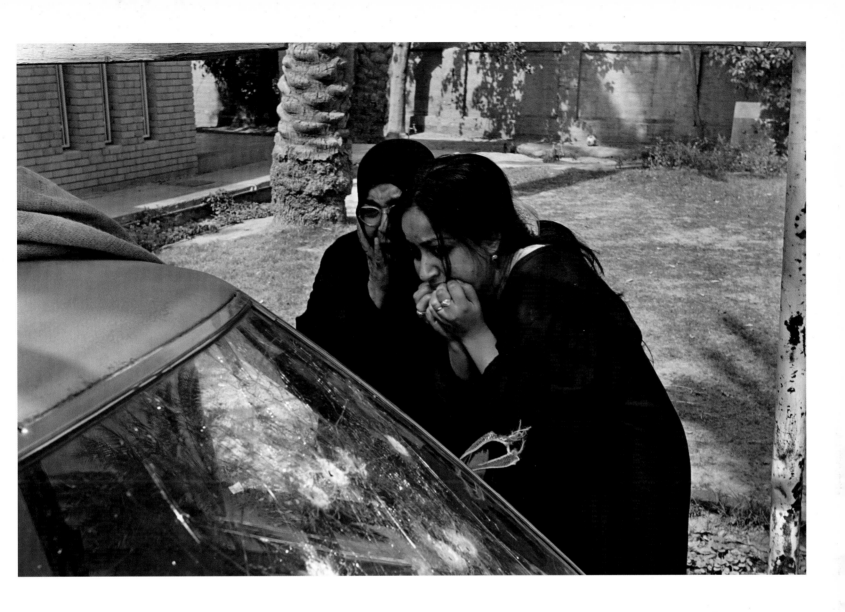

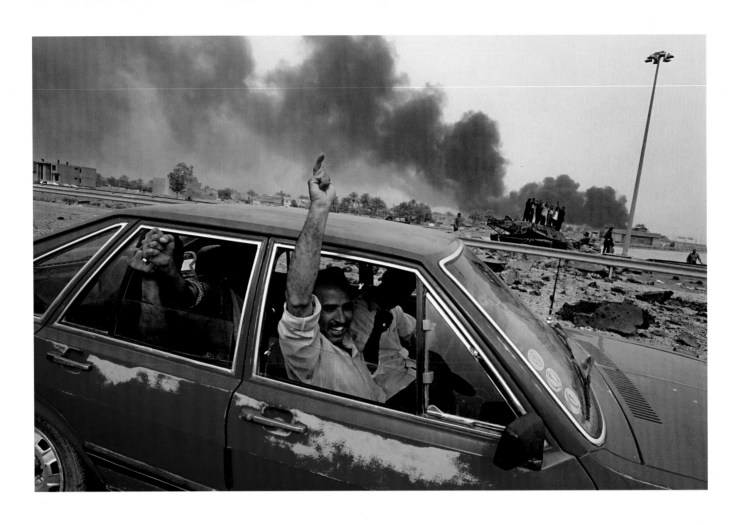

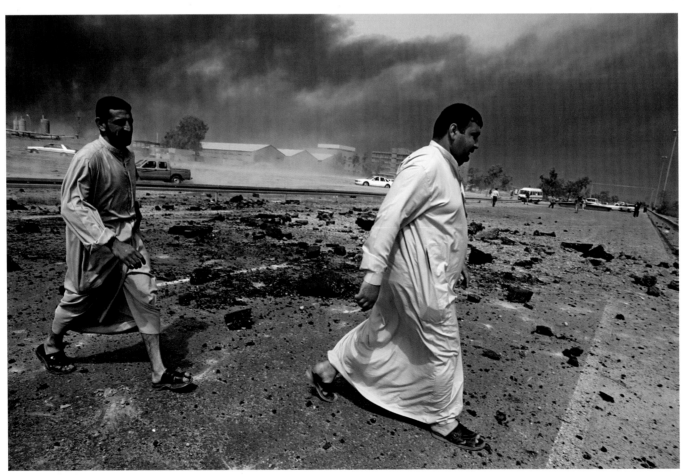

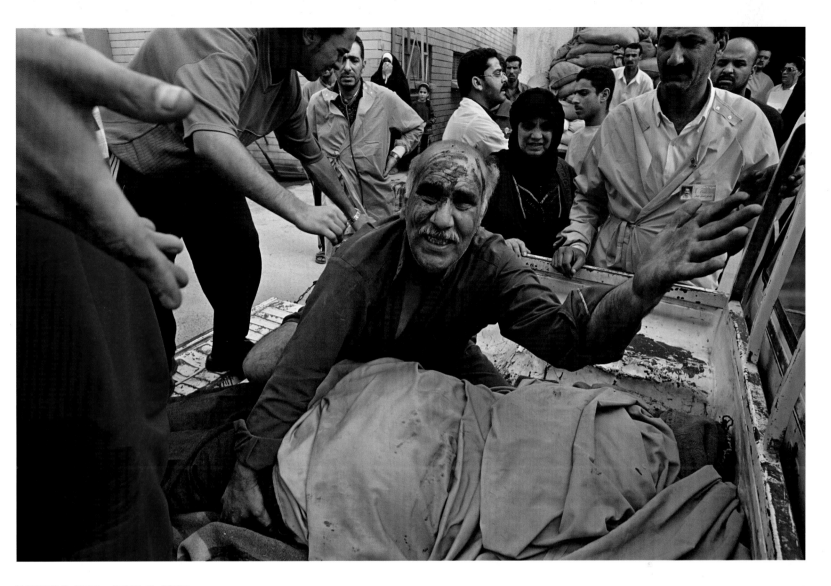

BAGHDAD, IRAQ. APRIL 8, 2003
A man cries over the body of a relative after family members
rushed him to Al Kindi Hospital in the back of a pickup truck.
This hospital became extremely busy as the Americans closed in
on the city, with many Iraqi civilians and soldiers arriving dead or
injured. With hospital supplies limited even in the best of times
in Iraq, a severe shortage of beds, only sporadic electricity and
no means to maintain a sterile environment, the situation for
those brought here was grim.

Opposite:
BAGHDAD, IRAQ. APRIL 6, 2003
Iraqis celebrate from their car where an American tank was
destroyed while fighting with Iraqi soldiers on the highway in
Doura, a southern suburb of Baghdad.

BAGHDAD, IRAQ. APRIL 6, 2003
Iraqi civilians cross the rubble-strewn street at the scene where
an American tank was destroyed.

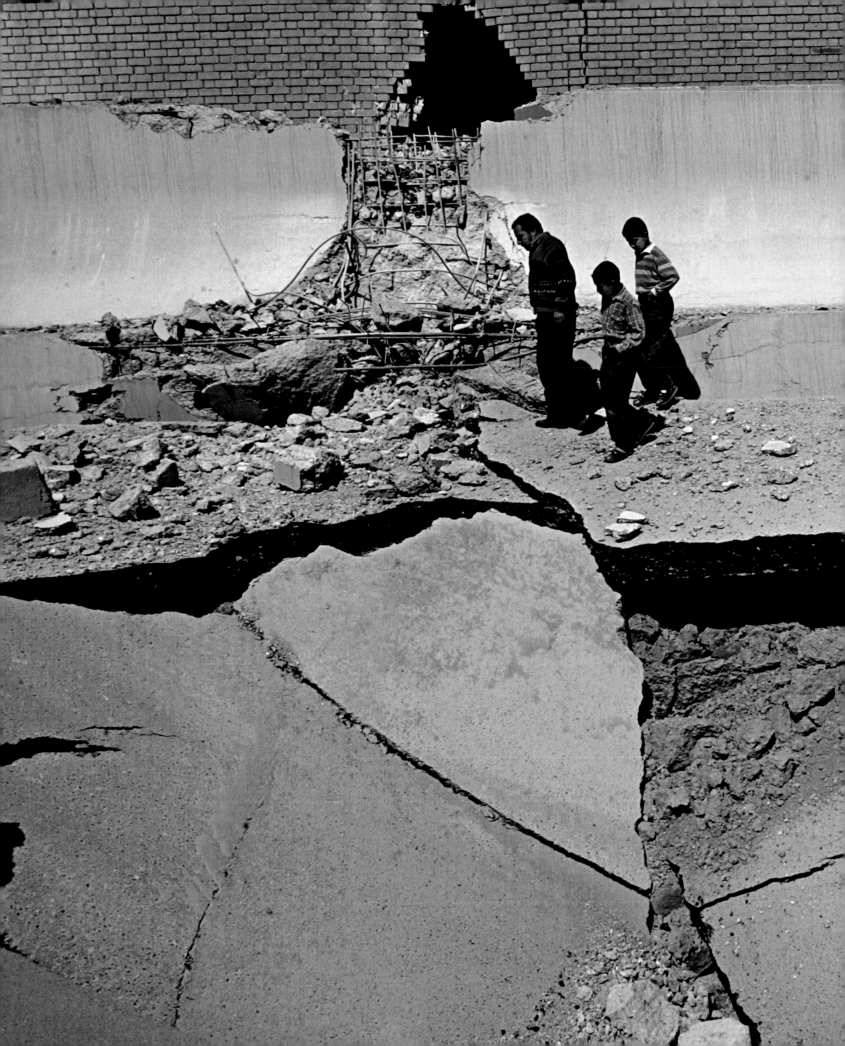

BAGHDAD, IRAQ.
MARCH 28, 2003
A large crater and collapsed road at a major communications building serving Baghdad, bombed by Americans the evening before. Outside of bombing palaces (in hopes of killing Saddam Hussein or anyone inside his inner circle) disabling communications in Iraq was one of the chief ambitions of the American military.

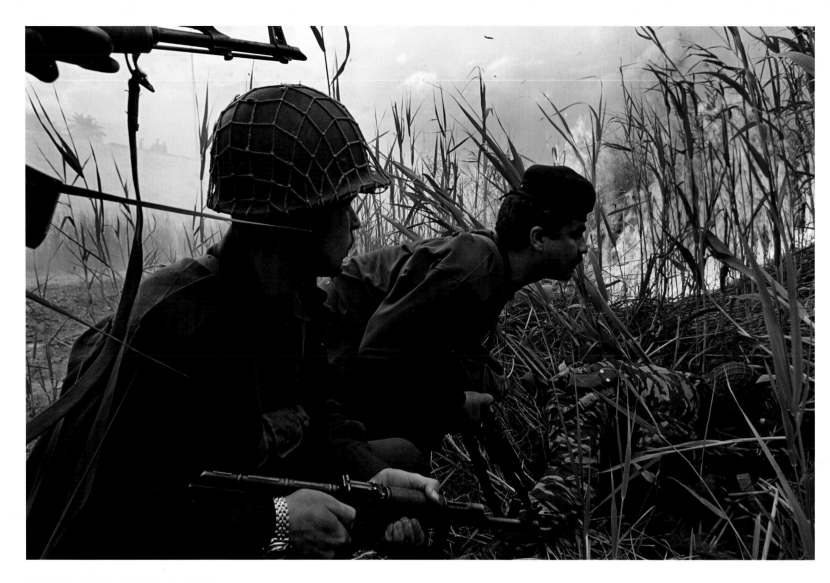

BAGHDAD, IRAQ. MARCH 23, 2003
Iraqi soldiers on the Tigris river bank in central Baghdad burning
bulrushes as they search for an American or British pilot eyewit-
nesses claimed to see parachuting into the river. Eight hours
later the search was still continuing about a mile further down
the river on the opposite bank.

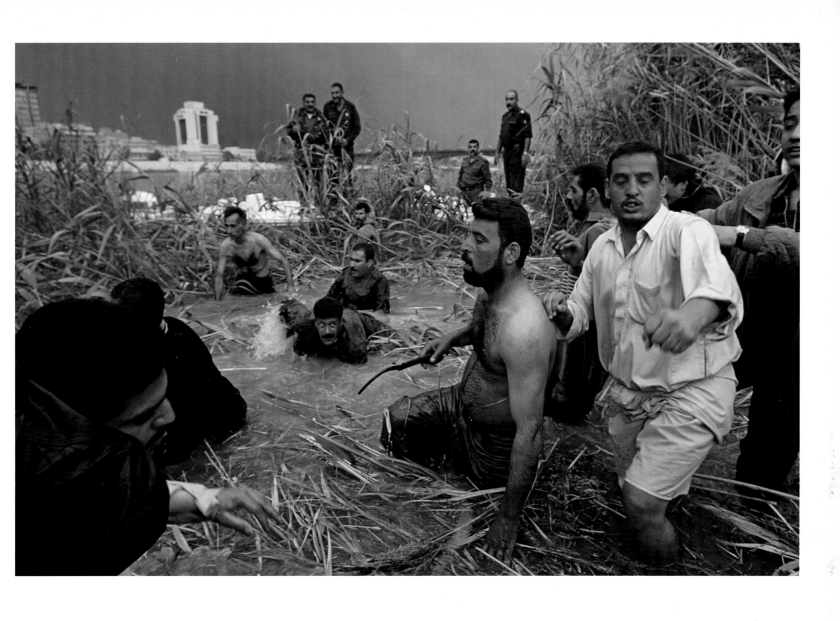

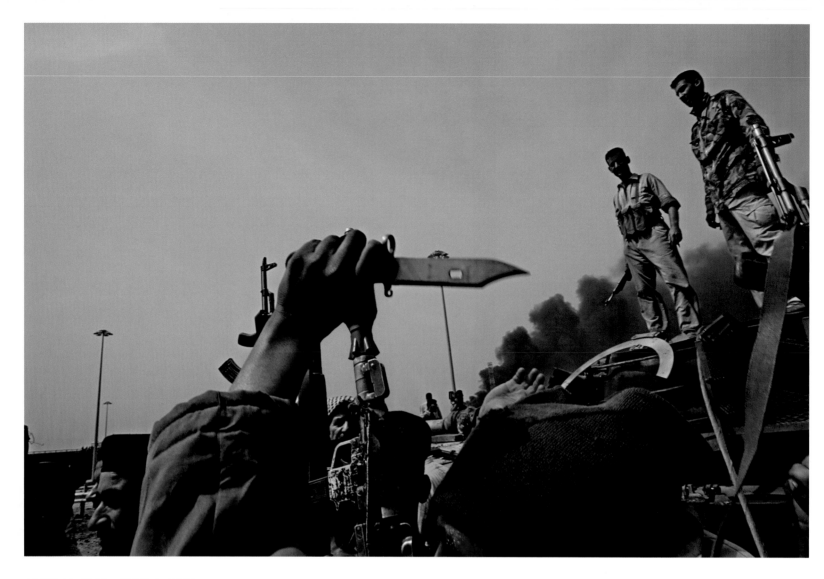

BAGHDAD, IRAQ. APRIL 6, 2003
Iraqi soldiers at the scene where an American tank was
destroyed. Some reports suggest that Americans may have been
injured in this tank, but were rescued before it was demolished.

BAGHDAD, IRAQ. APRIL 9, 2003
Iraqis display the Iraqi flag where a statue of Saddam stood as
they celebrate the arrival of Americans in Central Baghdad in
front of the Palestine Hotel.

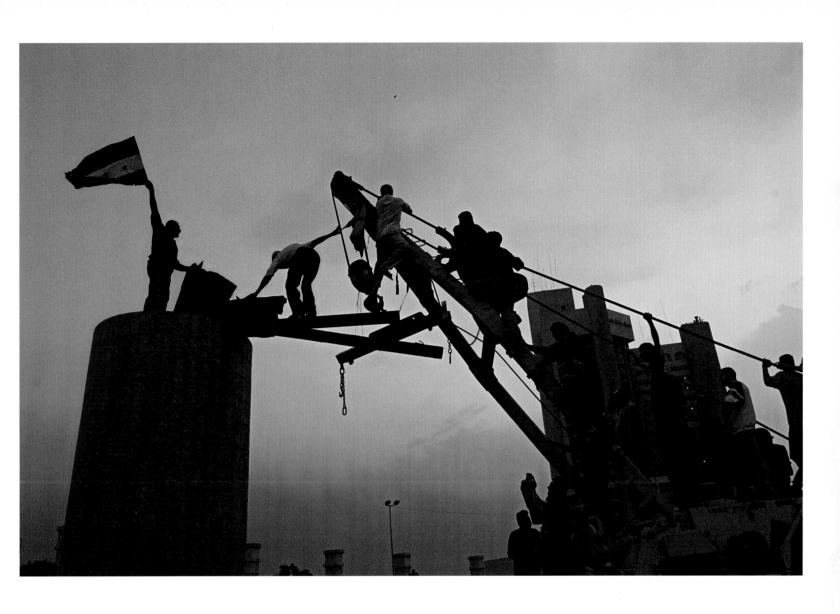

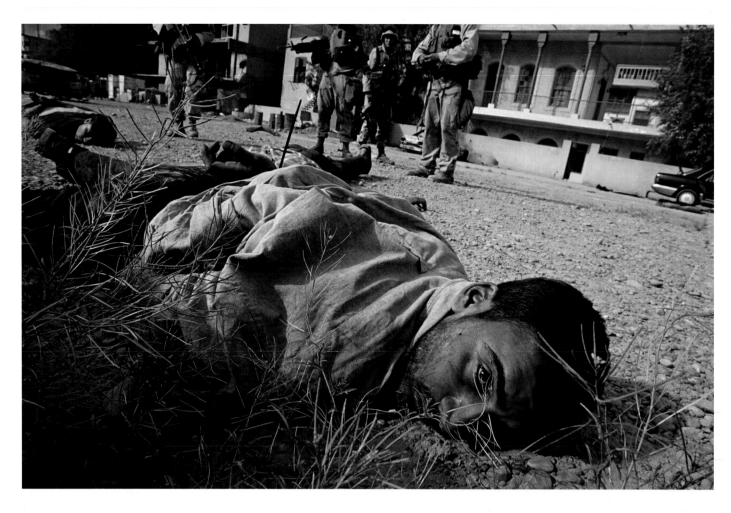

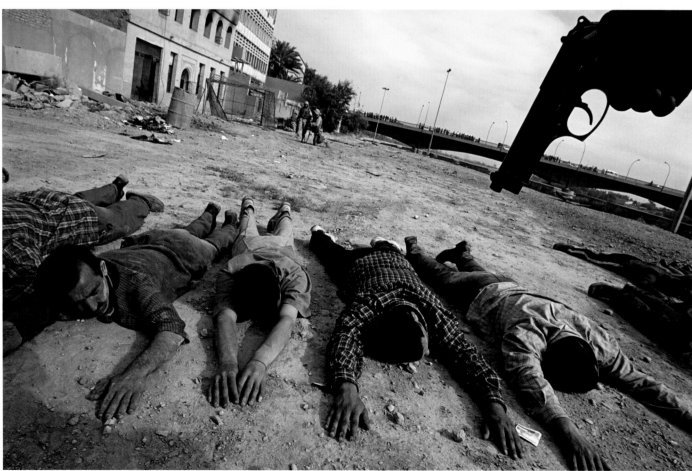

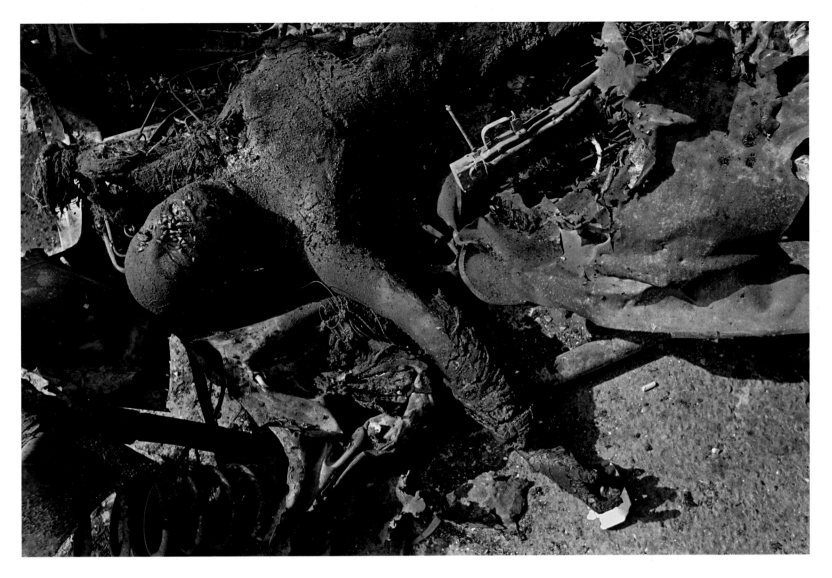

BAGHDAD, IRAQ. APRIL 10, 2003
The charred body of an Iraqi soldier lays on the Jumhuriya
Bridge. American forces primarily entered from the western side
of the river and proceeded over this bridge to secure a larger part
of the city.

Opposite:
BAGHDAD, IRAQ. APRIL 13, 2003
Iraqi men detained at gunpoint by American Marines after being
rounded up on the east side of the Tigris River at the foot of the
Jumhuriya Bridge. One Iraqi man, shown in this picture, shot
and injured another Iraqi when the Marines moved in to calm the
escalating situation. A total of thirty-two men were detained at
the scene, then twenty-nine were released and three arrested and
taken away by the Americans. A Kalashnikov, bayonets, and
ammunition were confiscated from some of the men. Looting
and crime continued in the city where there are no police.

BAGHDAD, IRAQ. APRIL 13, 2003
Iraqi men suspected of looting are detained at gunpoint by
American Marines near the Tigris River at the foot of the
Jumhuriya Bridge in Baghdad.

The vast, fortified palaces where Saddam Hussein and his family lived have for years been a symbol of his wasteful and self-serving use of money in a country where wealth reached only a privileged few. The American bombs dropped over Iraq largely targeted these ornate buildings, collapsing their roofs and domes and demolishing their marble interiors. Seeing these structures up-close offered a more interesting insight to these clandestine homes; much of the materials used were cheap, the feeling inside hollow like a movie set.

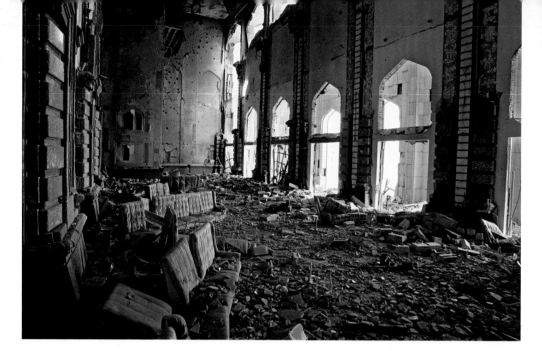

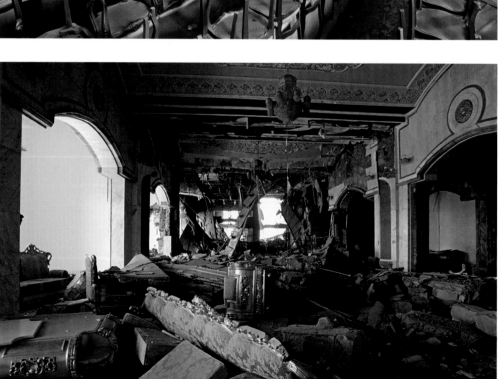

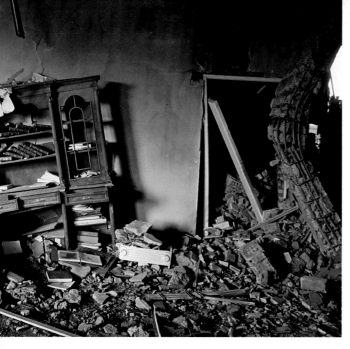

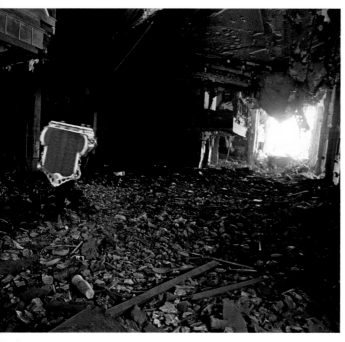

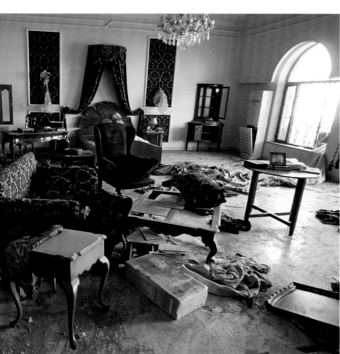
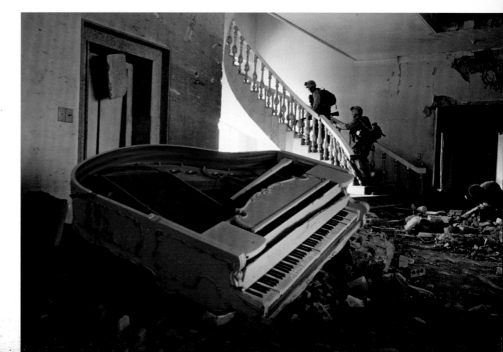

SAMMARA, IRAQ. DECEMBER 23, 2003
U.S. Soldiers from the Fifth Battalion, Twentieth Infantry Regiment, also known as the Stryker Brigade (Alpha Company) patrol the streets of the northeastern section of Samarra in the late hours of the night.

AD DULUIYAH, IRAQ. DECEMBER 22, 2003
With glow sticks lighting their way, soldiers search belongings in a house during a late night raid in Ad Duluiyah. Women and children gathered in this room as soldiers searched the rest of the house. Adult men were detained in a separate room.

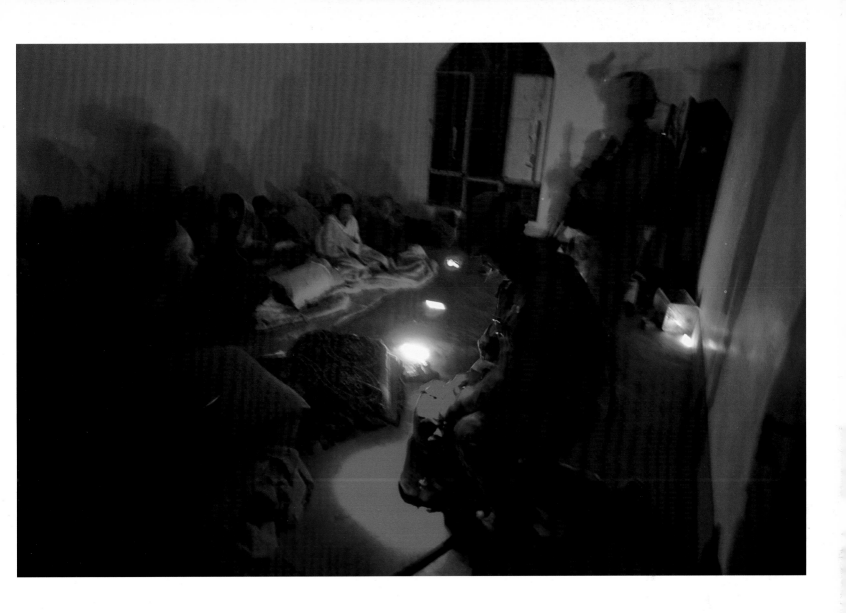

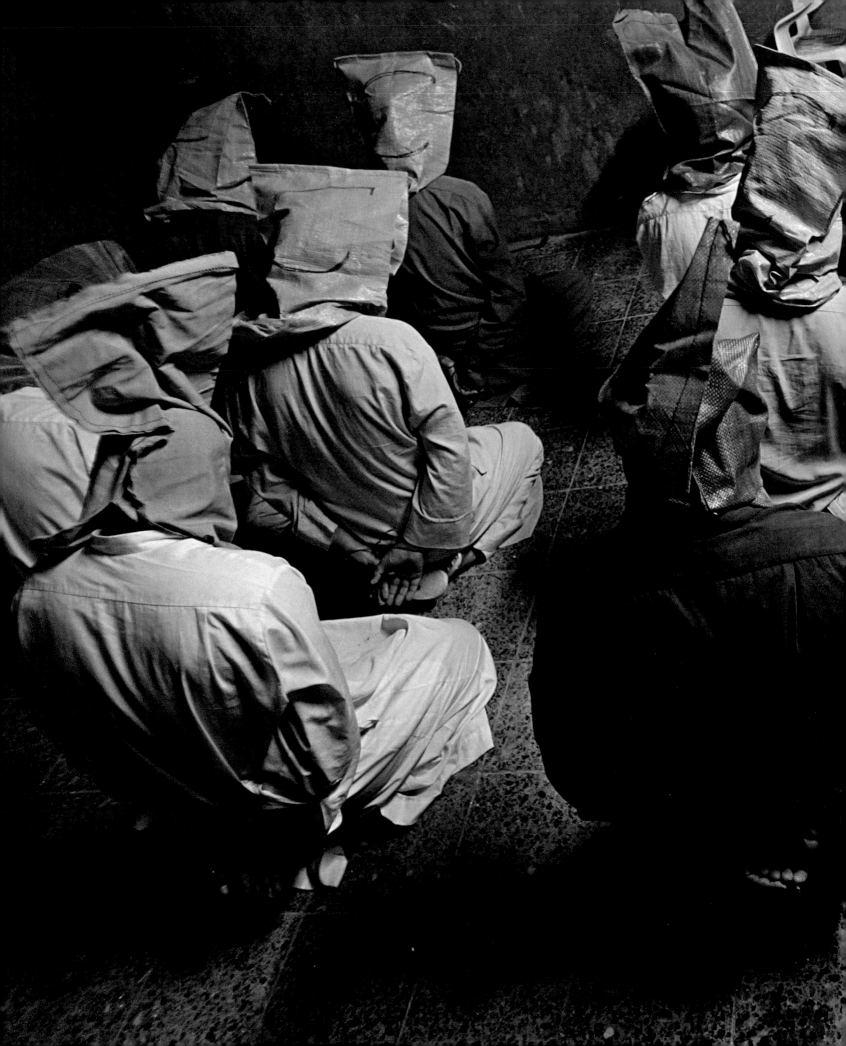

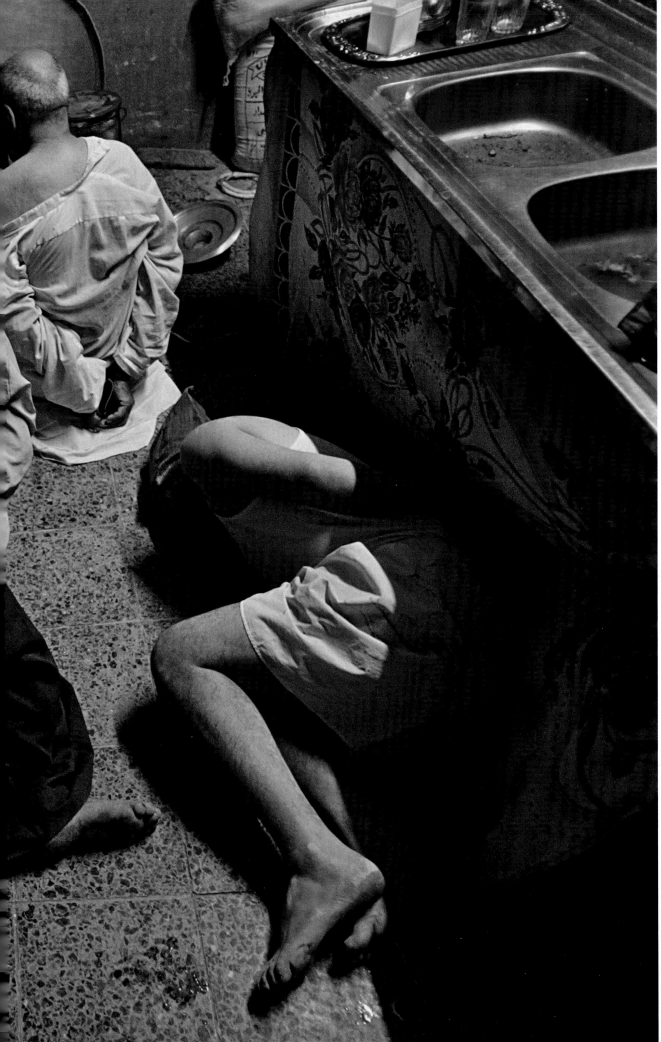

Iraqi men are detained
with sacks covering
their heads in a kitchen
during a raid by
Americans on a com-
pound of homes thirty
kilometers north of
Baghdad near the town
of Tarmia.

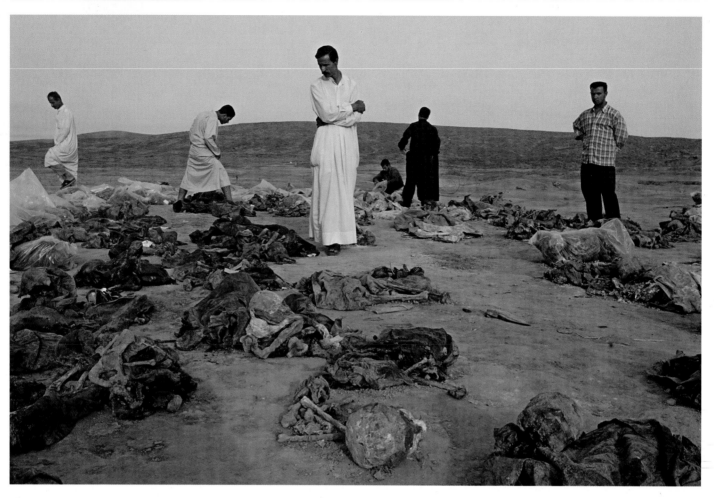

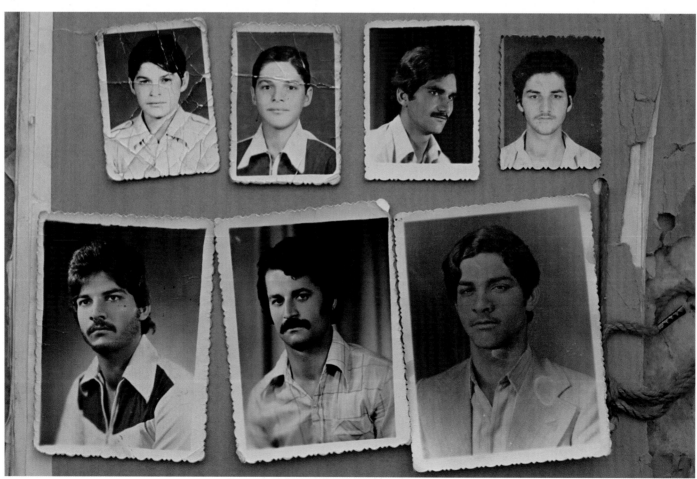

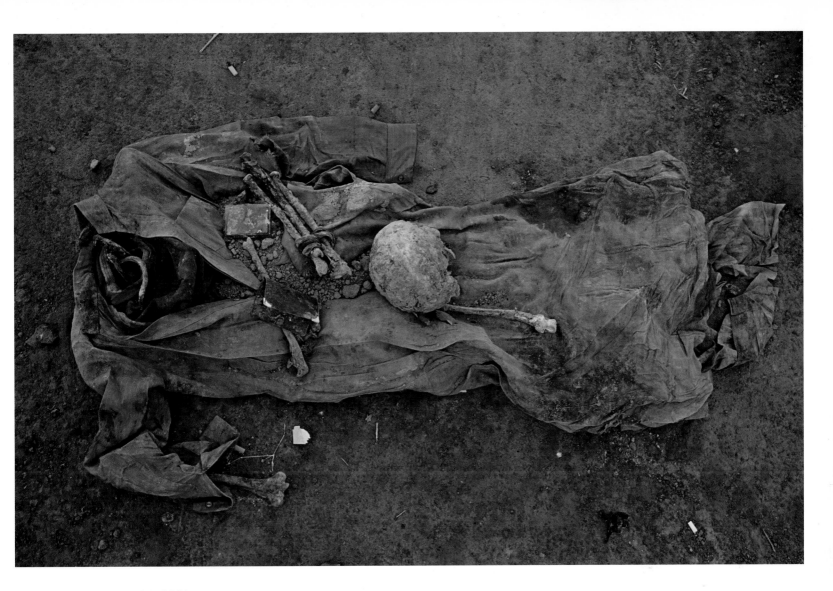

MAHAWIL, IRAQ. MAY 14, 2003
At the site of the largest atrocity discovered since U.S. forces
overthrew Saddam Hussein, Iraqi villagers exhumed the remains
of up to 3,000 people from a mass grave in Mahawil, sixty miles
south of Baghdad. They were believed to have been killed dur-
ing the 1991 Shiite revolt against Saddam Hussein's regime.
Digging continued throughout the day and many more bodies
were found.

Opposite, below:
BAGHDAD, IRAQ. APRIL 27, 2003
Photographs on the wall of Hamid Naji Hamoudi's seven brothers
who dissapeared and are feared dead. The organization contains
cemetery records and other documents, including orders for exe-
cutions, relating to political prisoners in Iraq. Hundreds of con-
cerned relatives gather here daily to search for missing persons.

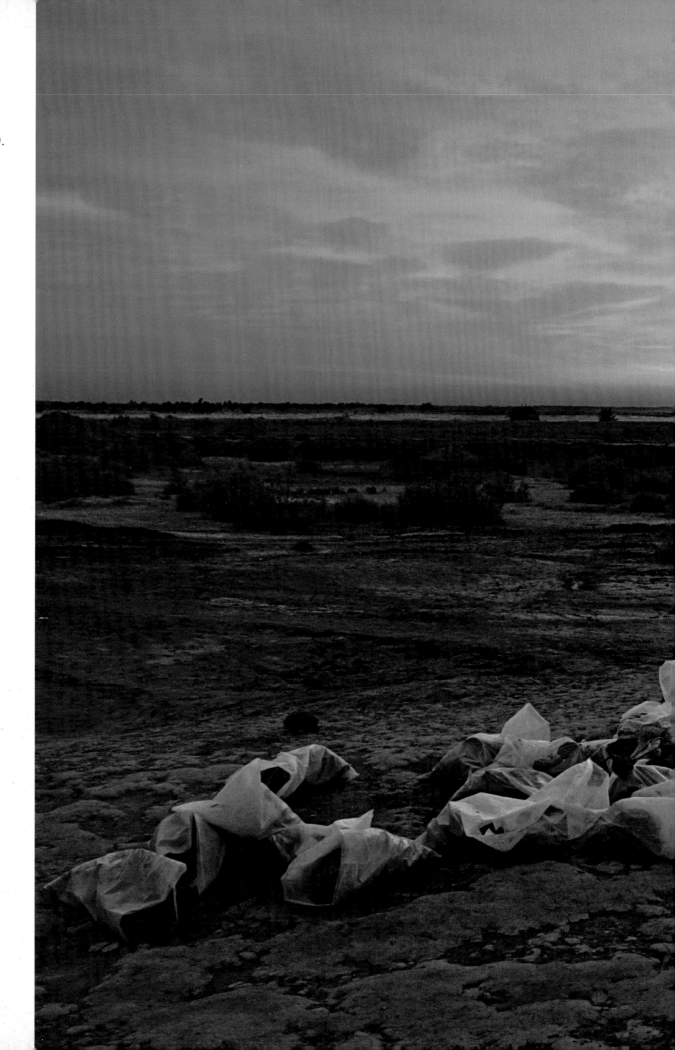

**MAHAWIL, IRAQ.
MAY 14, 2003**
The sun rises over the
Mahawil. Saddam had
killed more than
350,000 people since
he took power in 1979.

110

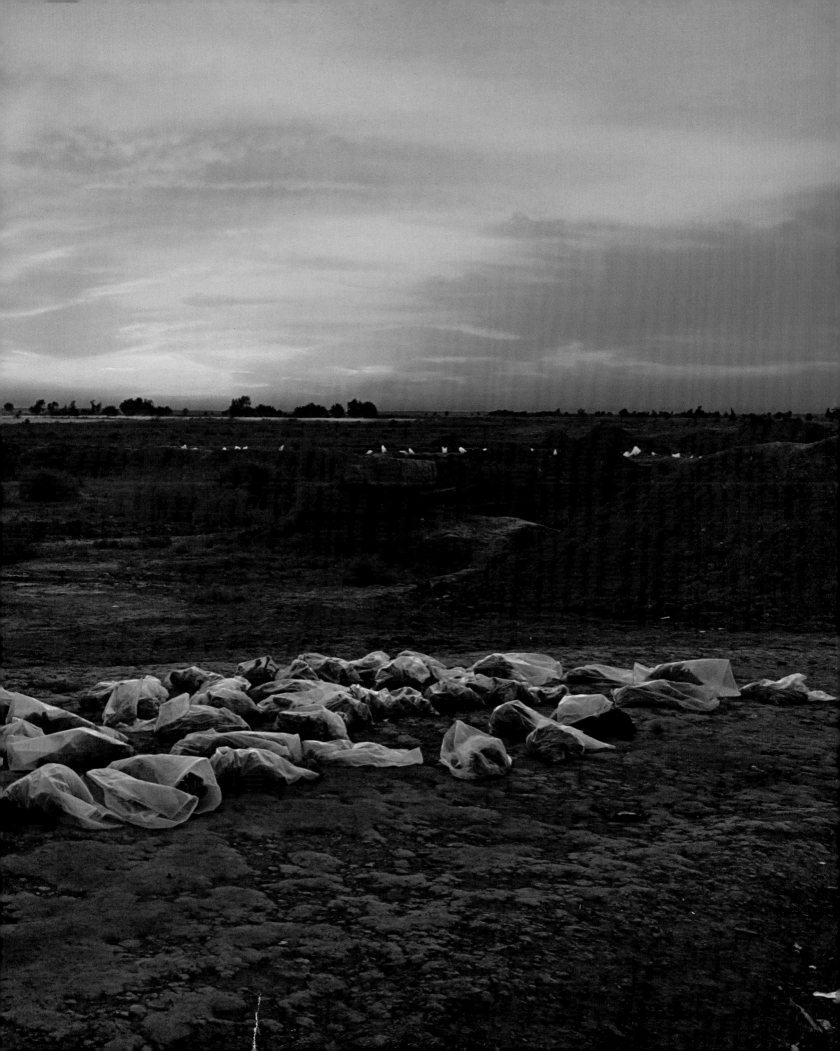

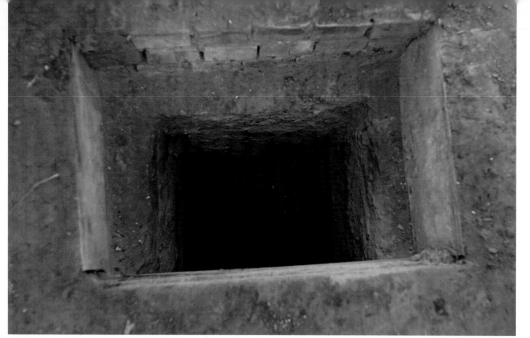

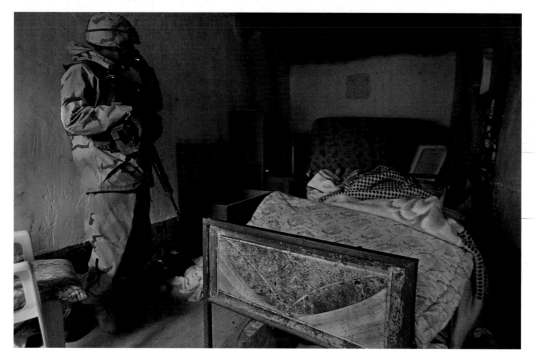

AI-DOUR, IRAQ. DECEMBER 15, 2003
The small dug-out hole where Saddam was hiding at the time of his arrest.

AI-DOUR, IRAQ. DECEMBER 15, 2003
An American soldier smokes a cigarette in the bedroom where Saddam Hussein had been living just prior to his capture.

AI-DOUR, IRAQ. DECEMBER 15, 2003
The kitchen inside the compound where Saddam Hussein had been living.

Opposite:
OWJA, IRAQ. AUGUST 2, 2003
During the funeral for Uday Saddam Hussein, his brother Qusay and Qusay's son Mustafa, local Tikritis close to the family throw hand-fuls of dirt over a casket containing the body of Mustafa at a cemetary in Owja. Saddam Hussein's mother is also buried here.

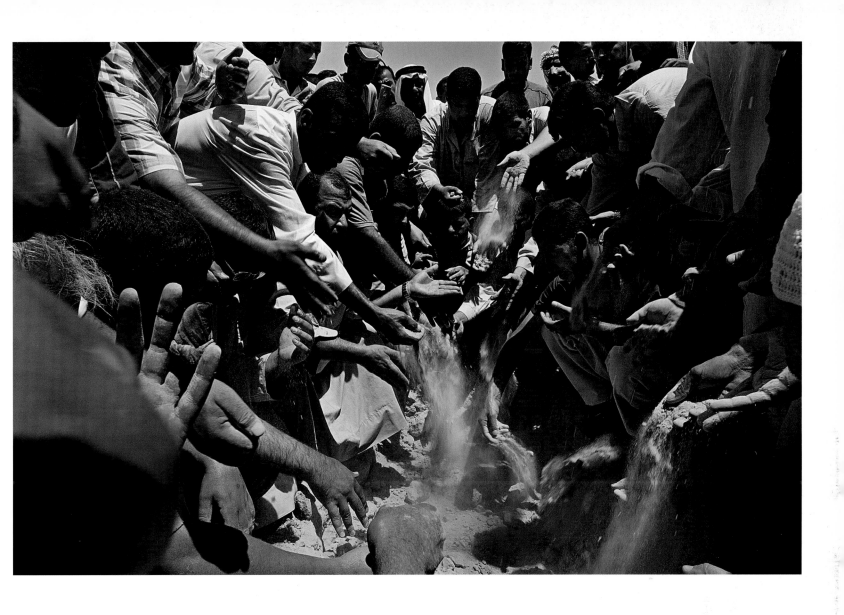

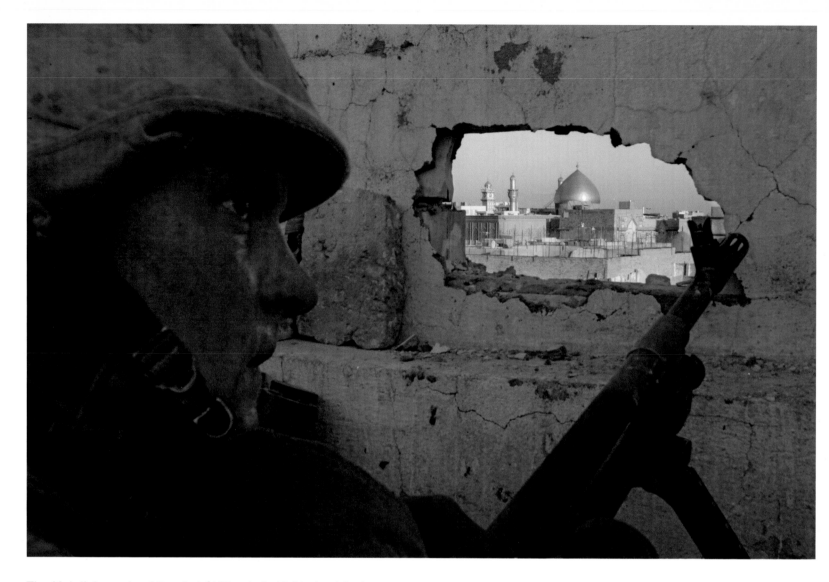

The Mahdi Army, loyal to rebel Shiite cleric Moktada al-Sadr, attacked a police station after the arrest of one of his aides. The situation escalated when he turned the Imam Ali Shrine, one of the holiest sites for Shiite Muslims, into a base where he fought American forces and challenged the Iraqi government to expel him. Weeks of fighting resulted in hundreds of Iraqi deaths and damaged the holy shrine. American forces, both Army and Marines, also suffered casualties during the standoff, which involved some of the heaviest urban combat the American military has seen. In the end the Shiite leader, Grand Ayatollah Ali al-Sistani, negotiated with Mr. Sadr and Interim Prime Minister Ayad Allawi, ending the standoff.

NAJAF, IRAQ. AUGUST 26, 2004
First Battalion, Fourth Marines watch the Imam Ali Shrine as they continue to receive sniper fire in Najaf, a day before negotiations ended a three-week standoff.

NAJAF, IRAQ. AUGUST 22, 2004
American Army soldiers from Charlie Company, First Battalion of the Fifth Cavalry Division display a poster of Shiite cleric Moktada al-Sadr from their tank.

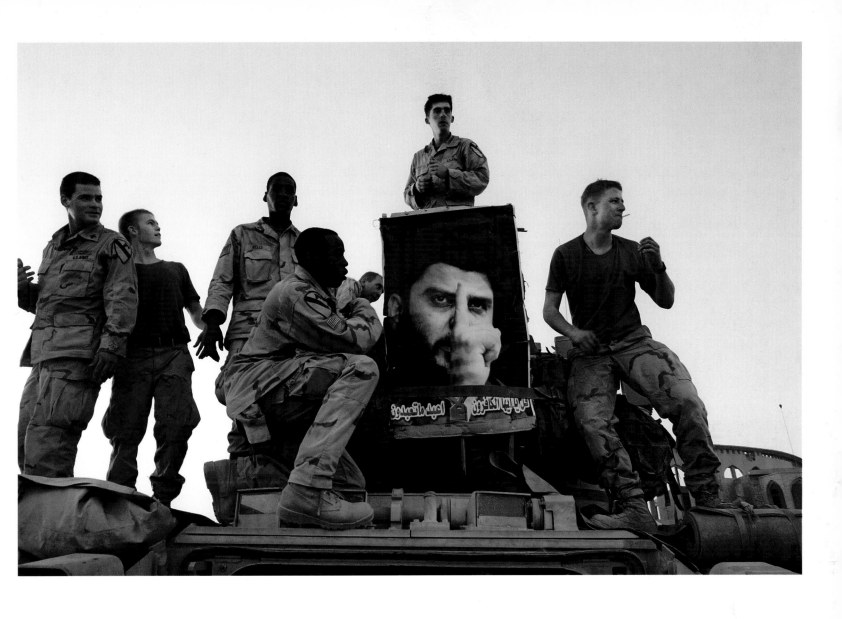

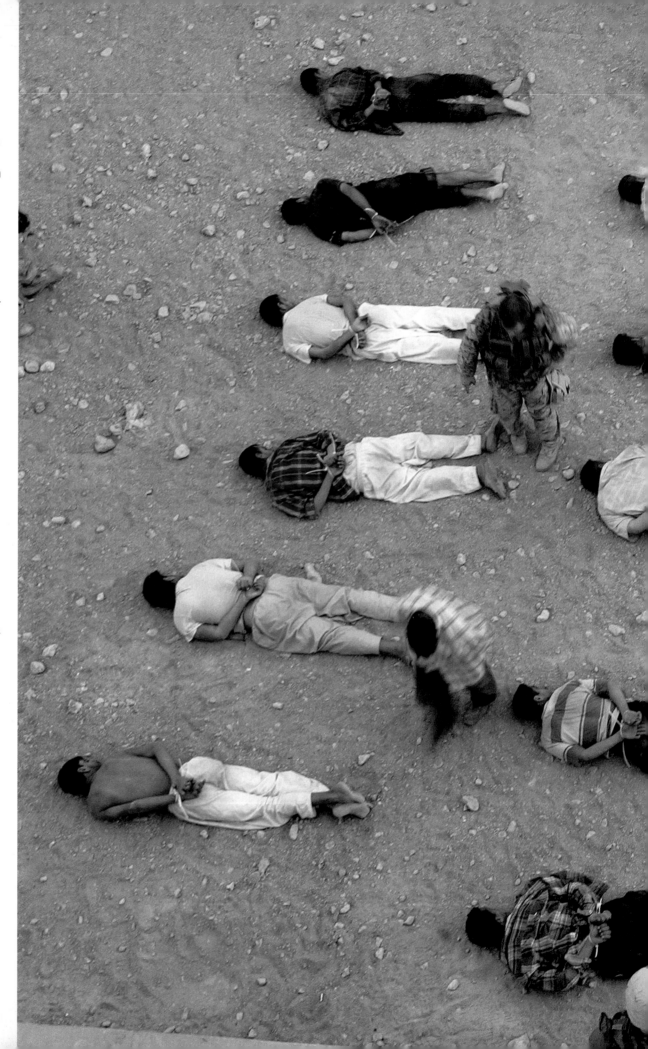

NAJAF, IRAQ.
AUGUST 21, 2004
Marines watch over Iraqi detainees gathered in Najaf, following an early morning raid on a former Iraqi police station in Kufa which was a gathering place for Mahdi militiamen loyal to radical cleric Moktada al-Sadr. Some of the twenty-nine captives claimed they had been held hostage because they wouldn't cooperate with the militia. They were turned over to Iraqi authorities for further questioning.

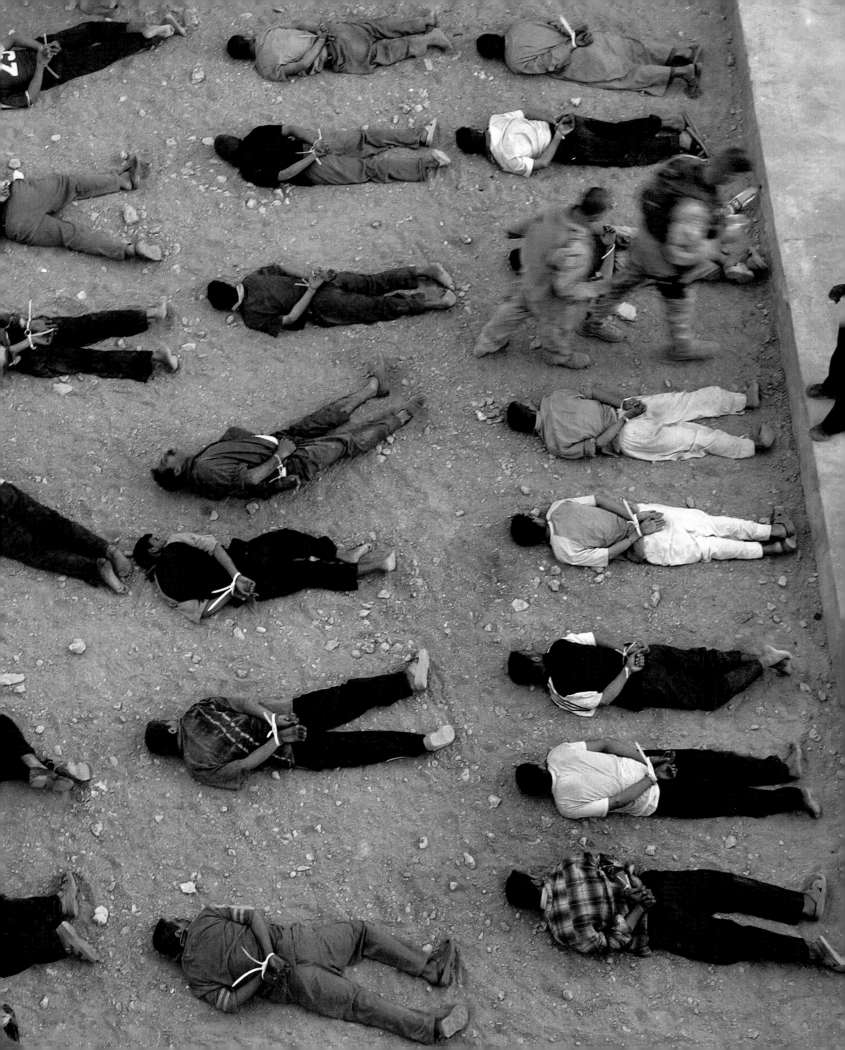

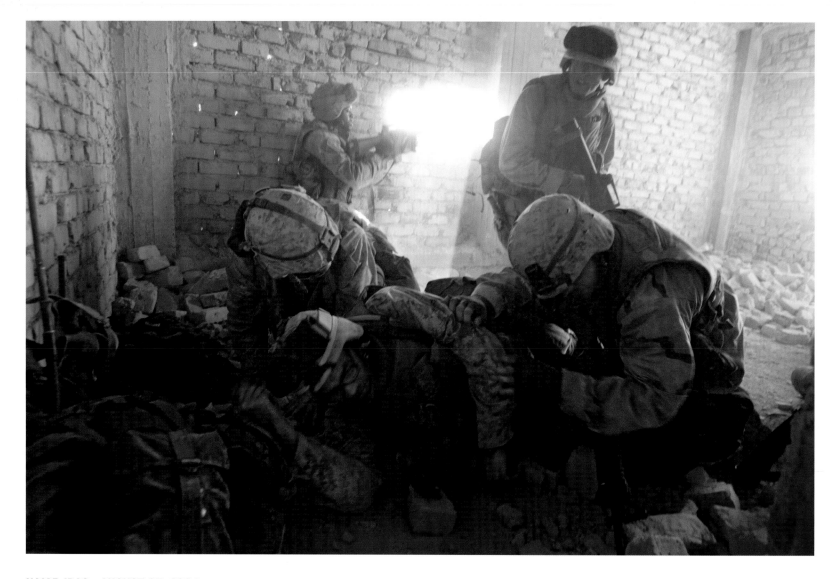

NAJAF, IRAQ. AUGUST 25, 2004
Marines moved closer to the Shrine, advancing under darkness in
the early morning and securing several buildings in the area.
Once in place, the Marines recieved heavy sniper fire, as well as
mortar and RPG attacks from Mahdi Army militias. Three
Marines were killed in action in the operation and twelve others
wounded before negotiations ended the standoff. Marines rush
to the aid of another as they recieve heavy sniper fire from Mahdi
Army militia.

NAJAF, IRAQ. AUGUST 15, 2004
A U.S. Army soldier cries after an attack on his unit by the
Madhi Army killed two Army soldiers at the cemetery. One day
after the ceasefire collapsed, eight Americans had been killed in
Najaf.

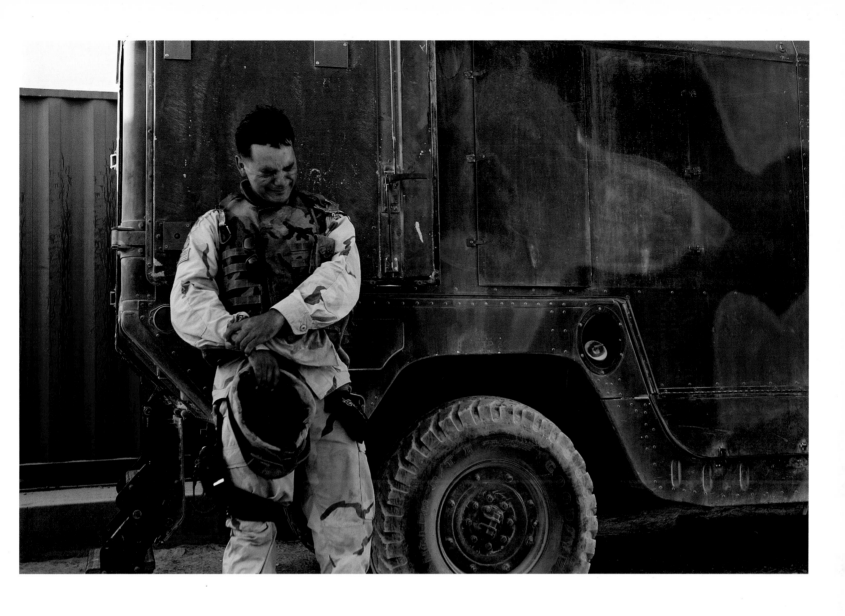

BAGHDAD, IRAQ.
NOVEMBER 25, 2003
Iraqi Shiite shop in preparation for Eid, ending the holy month of Ramadan for Shiite Muslims. Large meals are prepared to break the fast.

BAGHDAD, IRAQ.
DECEMBER 12, 2003
Saleh Ibrahim Mohommad, blinded in a suicide bomb attack on the police station where he worked, is helped in his kitchen by his son, Mehdi.

BAGHDAD, IRAQ.
APRIL 23, 2003
Shiite men enter the front doors of Khadimiya Mosque. The Shiite sect is now able to express their religion freely.

BAGHDAD, IRAQ.
JULY 1, 2004
Iraqi men watch Saddam Hussein during his court appearance on a television broadcasting an Arab news program.

BAGHDAD, IRAQ.
DECEMBER 10, 2003
Three Iraqis were killed here when two explosives blew a hole in a wall of a mosque.

TARMIA, IRAQ. JUNE 29, 2003
Soldiers break for a smoke during a raid by Americans on a compound of homes north of Baghdad.

BAGHDAD, IRAQ.
NOVEMBER 25, 2003
Iraqi Shiite shop in an open bazaar in preparation for Eid.

BAGHDAD, IRAQ.
JULY 17, 2003
Iraqi men smoke and drink tea at Casino Al Zahawi.

BAGHDAD, IRAQ. MAY 5, 2003
An Iraqi boy dives into a fountain in front of the Fourteenth of Ramadan Mosque.

120

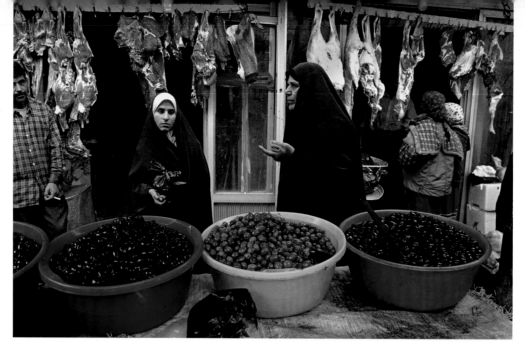

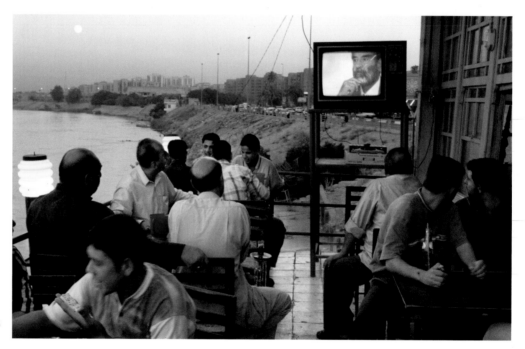

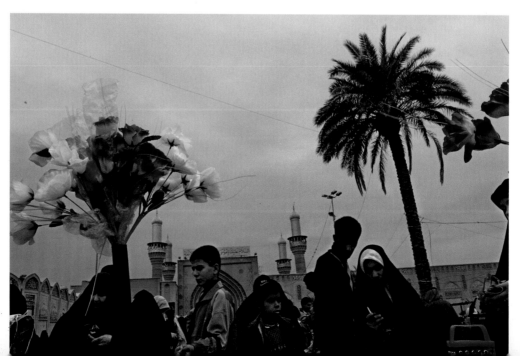

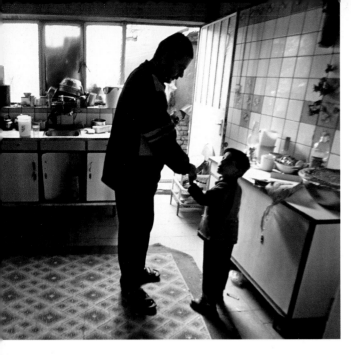
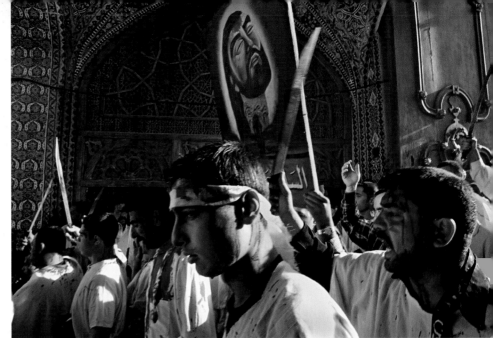

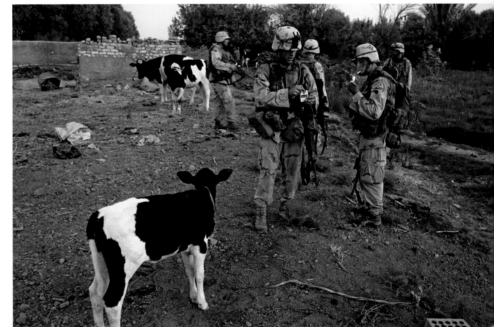
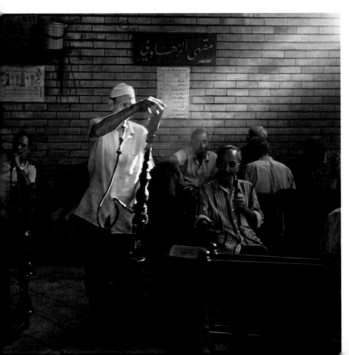
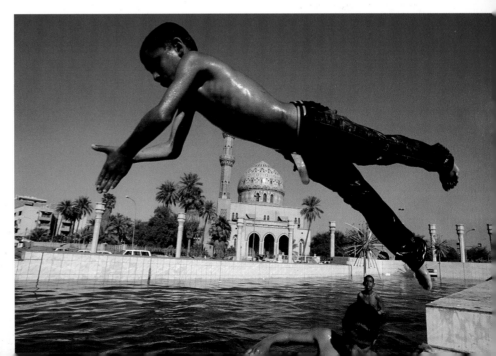

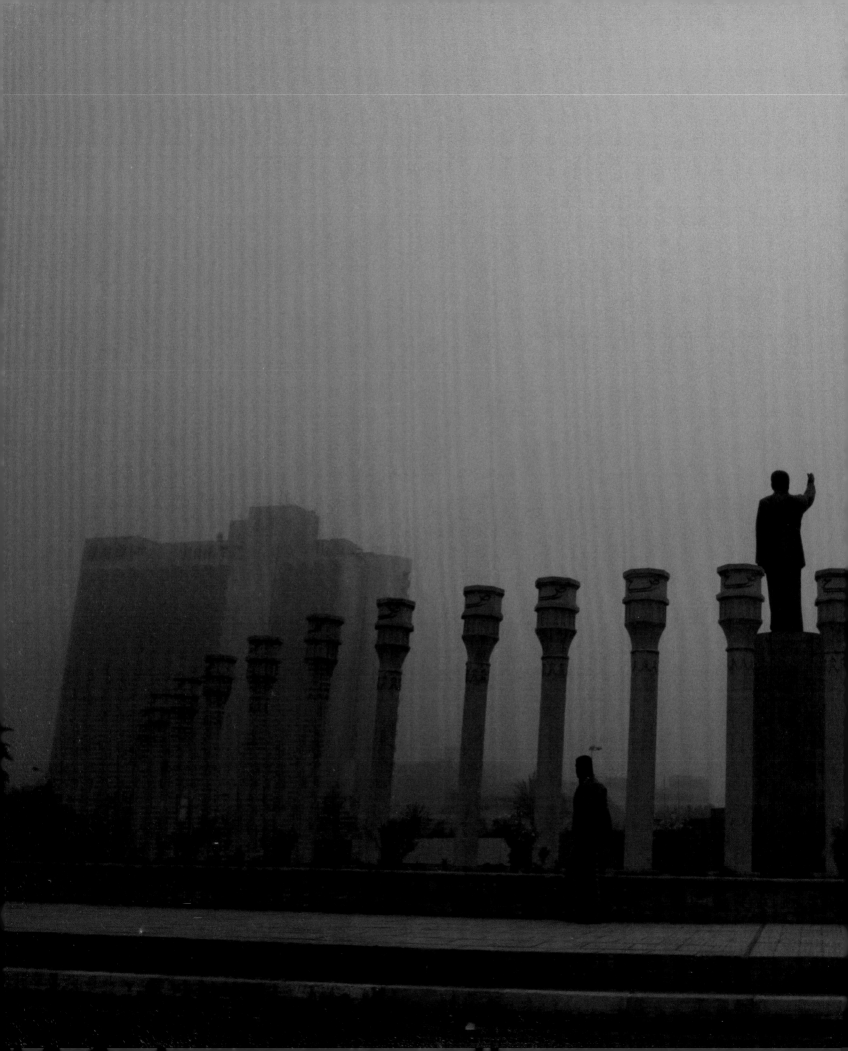

**BAGHDAD, IRAQ.
MARCH 25, 2003**
A sand storm created
limited vision and an
orange cast in the sky
behind a statue of
Saddam Hussein.
Baghdad remained rela-
tively quiet throughout
the day, with the occa-
sional rumble of explo-
sions heard from contin-
ued bombing.

TIMELINE

AFGHANISTAN

1919 Afghanistan defeats Britain in the third British-Afghan war and becomes an independent nation. Emir Amanullah Khan declares Afghanistan a monarchy and names himself King, beginning a series of reforms in an attempt to modernize Afghanistan, including the abolition of the traditional Muslim veil and the opening of many co-educational schools.

1921 Afghan-Soviet Treaty of Friendship signed.

1965 Babrak Karmal leads the secret formation of the communist People's Democratic Party of Afghanistan (PDPA). In 1967, the PDPA splits into two rival factions; the Khalq (Masses) led by Nur Muhammad Taraki and Hafizullah Amin, and the Parcham (Banner), led by Babrak Karmal.

1971-72 Afghanistan is hit with a severe drought, which devastates the country's agriculture-based economy.

1973 Former Prince Daoud Khan seizes power in a military coup and ousts his cousin, sitting King Mohammed Zahir Shah. Daoud abolishes the monarchy, declares Afghanistan a republic, and names himself President and Prime Minister. He is supported by the PDPA and establishes close ties with the Soviet Union. Dauod's attempts at socioeconomic reforms are unsuccessful; dissatisfaction grows.

1978 The rival factions of the PDPA work together to overthrow Daoud, ultimately killing him and most of his family. Taraki is named President and Prime Minister. Taraki signs a friendship treaty with the Soviet Union, which provides military assistance to the new regime. The mujahadeen guerilla movement forms in opposition. The United States provides the mujahadeen with weapons and training.

1979 In September, PDPA colleagues Taraki and Amin engage in a power struggle that leads to a palace shootout and Taraki's death. Amin assumes control but struggles to maintain his power. By December, relations between the Soviets and Amin deteriorate and the Soviet Union invades Afghanistan. Amin and many of his followers are killed. Babrak Karmal is installed as Prime Minister to widespread opposition.

1980 Mujahadeen rebels unite against Soviet armed forces.

1982 Over four million people flee Afghanistan. The fighting continues as Afghan guerillas take control of rural areas and Soviet troops control the cities.

1986 Unpopular with both Afghans and Soviets, Prime Minister Karmal is replaced by Muhammad Najibullah, former chief of the Afghan secret police, supported by the Soviets. The mujahadeen are now receiving arms from the U.S., Great Britain, and China.

1988-89 The U.S., Pakistan, Afghanistan, and the Soviet Union sign peace accords in Geneva. The U.S. and the Soviet Union agree to non-interference in the internal affairs of Afghanistan and Pakistan and to the withdrawal of Soviet troops. In the ten years since fighting began, an estimated one million Afghanis lost their lives. Najibullah remains in power, and the mujahadeen continue resistance.

1992 The mujahadeen storm Kabul, ousting Najibullah from power. The Islamic Jihad Council is created as a governing body. Burhannudin Rabbani is elected President. Conflict between Jamiat-i-Islami and Hezb-i-Islami, rival factions within the rebel fighters, drive the country into chaos. Rabbani manages to control Kabul and the northeast while local warlords scramble for power in the rest of the country.

1994 A newly formed group called the Taliban (made up of former mujahadeen fighters and Islamic militants) takes control of the city of Kandahar. After years of anarchy, the Taliban gains popular support, with its call for order and commitment to upholding Islamic tradition. The Taliban cracks down on crime and outlaws the cultivation of poppies for the opium trade. It implements severe restrictions on women: the full veil is now required, women can no longer attend school or work, and they cannot leave the house unless accompanied by a male relative.

1998 The Taliban's powers continue to grow, covering nearly all of Afghanistan. Despite sanctions from the United Nations, the Taliban provides a base for Saudi-born militant Osama bin Laden and the radical Muslim alliance Al Qaeda, as well as other terrorist organizations.

2001 Terrorists attack the U.S. on September 11, killing thousands. Osama bin Laden and Al Qaeda are behind the attacks. Following the Taliban's refusal to expel bin Laden, the U.S. begins attacking Afghanistan with the goal of displacing the Taliban from power. The campaign begins on October 7; by November 13 the U.S. has gained control of Kabul, installing Hamid Karzai as President.

2002 The government is renamed the Transitional State of Afghanistan.

2003 Attacks by remnants of the Taliban on American forces, coalition peacekeepers, humanitarian workers, civilians, and journalists continue.

2004 Afghanistan accepts a new national constitution at the beginning of the year, declaring the country an Islamic Republic. The country relies heavily on foreign aid to provide its citizens with basic services and food. The government's authority beyond Kabul slowly grows, as does a fresh crop of opium. Presidential elections have been scheduled for October as this book went to press.

Sources: U.S. State Department, *PBS NewsHour*, *The War Chronicle*

IRAQ

1914-1918 During World War I, Britain invades the territory that is now Iraq in the war against the Ottoman Empire. Arab nations join the Allied forces to defeat the Turkish forces. In return, they are promised independence and aid.

1919 At the Paris Peace Conference, it becomes clear that Allied promises of freedom will not be fulfilled. The victorious Western powers proceed to carve up dominion in the oil-rich area. Lawrence of Arabia presciently warns England and the world that unless those in Arab countries are granted their promised freedom and independence, his great-grandchildren might one day have to fight a war in Iraq wearing gas masks.

1920 Iraq is placed under British mandate by the League of Nations. Iraqis rebel immediately, raiding British establishments and killing British soldiers. Britain retaliates by burning entire villages until the revolt is crushed.

1921 Britain installs Faisal I as King, kidnapping his opponent to ensure victory. Faisal cooperates with the British yet fails to produce a sense of nationhood between the different peoples of his country. He and his descendents rule for the next thirty-seven years.

1932 Iraq is granted independence. Under the new treaty, Iraq is responsible for defending itself but Britain retains bases and the right to move troops through Iraq in the event of war.

1958 Abdel Karim Qassim and Abdal Salam Muhammad Arif lead a military coup that overthrows King Faisal II. The King and many of his family members are executed. Iraq becomes a republic and Qassim is named Prime Minister.

1959 A young Saddam Hussein attempts to assassinate Qassim. His attempt fails, and he flees Iraq for the next four years.

1963 Saddam Hussein and the Ba'ath party come into power by ousting Qassim in a bloody military coup. However, by November, lacking popular support, the Ba'athist government is overthrown by Arif and a group of army officers. Arif becomes President.

1966 Arif dies in a helicopter crash and his older brother assumes the presidency.

1968 A second coup by the Ba'ath Party displaces the elder Arif. Ahmad Hasan al-Bakr declares himself president and Saddam Hussein takes on the role of Vice President.

1970 The Revolutionary Command Council (RCC) signs a peace agreement with the Kurdistan Democratic Party (KDP).

1972 Iraq signs a fifteen-year friendship treaty with the Soviet Union and nationalizes the Iraq Petroleum Company.

1975 At a conference of OPEC, Iraq and Iran sign a treaty ending border disputes.

1979 The Shah of Iran is ousted in an Islamic revolution. The exiled Ayatollah Khomeini returns to Tehran to take power. In Iraq, President al-Bakr steps down and is succeeded by Saddam Hussein. Hussein immediately purges the RCC of those he perceives as enemies.

1980 Border skirmishes between the two countries lead Iraq to launch a full-scale invasion of Iran: the beginning of the Iraq-Iran War. Iraq relies heavily on the USSR as a weapons provider.

1983 President Reagan sends envoy Donald Rumsfeld to Baghdad to establish American support for Iraq. Intent on preventing any further Islamic revolution in the region, the United States aids Iraq with intelligence, bombs, and biological and chemical weapons.

1984 The U.N. confirms Iraq's use of prohibited chemical weapons against Iran. The U.S. State Department condemns Baghdad's behavior but continues their support.

1988 The Iraq-Iran War ends in a stalemate. An estimated one million people were killed and millions more displaced.

1988 Saddam Hussein uses chemical weapons to crush a Kurdish rebellion in northern Iraq. Estimates are uncertain, but many thousands of Kurds are killed.

1990 Iraq invades Kuwait. In response, the U.N. Security Council calls for the immediate withdrawal of Iraqi troops.

1991 The U.S. launches a bombing campaign, "Operation Desert Storm," and begins the First Gulf War, driving the Iraqi army from Kuwait. Iraq agrees to the terms of a ceasefire, calling for an end to weapons of mass destruction programs, recognition of Kuwait, and an end to support for terrorism. Soon after, rebellions against Baghdad erupt in the north and south of Iraq. They are quickly suppressed with military force. A safe haven is created in the north of Iraq for protection of the Kurds.

1993 The U.S. launches a missile attack on Iraqi intelligence headquarters in Baghdad in retaliation for a failed assassination attempt on former President George H. Bush.

1995 The U.N allows Iraq to export oil in exchange for food and medicine.

1998 Saddam Hussein removes weapons inspectors from Iraq. The U.S. and Britain launch a bombing campaign to destroy any possible weapons programs.

2001 Following the September 11 terrorist attacks, President George W. Bush declares a "War on Terror."

2002 In his State of the Union address, President Bush declares Iraq, Iran, North Korea, and their terrorist allies members of an "axis of evil" that threatens world peace. Iraq dismisses U.N. weapons inspectors. Bush addresses the U.N., calling for multilateral action against Iraq. Iraq submits documentation of the disposal of its weapons of mass destruction. The U.S. rejects the document as incomplete and unconvincing.

2003 U.S. and Britain ask the U.N. Security Council for authorization of war with Iraq, but meet strong opposition from France, Germany, and most Arab countries. In March, President Bush gives Iraq forty-eight hours to turn over prohibited weapons. When Iraq fails to comply, the U.S. launches a strategic air strike on Saddam Hussein. War has begun. U.S. ground troops invade Iraq through the south and by April take control of Baghdad. Looting and chaos engulf the city. Bush declares an end to combat in Iraq on May 1. It is soon clear that there were no stockpiles of weapons of mass destruction, leaving the justification of the invasion unfulfilled. In October the U.N. Security Council recognizes the legitimacy of the American-supported provisional government. The occupying forces meet with resistance from a growing insurgency movement; guerilla warfare intensifies as the year goes on and the death toll mounts. By the year's end American forces capture Saddam Hussein in his hometown of Tikrit.

2004 The number of casualties grows. Over 100 people are killed in February suicide attacks on the main offices of the Kurdish faction. In March, 100 people are killed in attacks on Shia Muslims. The attacks are coordinated to strike mass gatherings. In the following months, Shia militias loyal to Moqtada Sadr launch an attack on American forces in Falluja. The U.S. holds the city under siege; hundreds are killed during fighting. In Baghdad, the head of the governing council, Ezzedine Salim, is killed in an explosion outside of headquarters. In May, a U.S. soldier leaks evidence that prisoners detained by American authorities in Abu Ghraib prison were tortured and humiliated. The abuses make headlines around the world and damage the already-thin credibility of the U.S. The transitional government takes power in a small and secretive ceremony on June 28, headed by Iyad Allawi and Ghazi Yawer, President and Prime Minister, respectively. As of September, over 145,000 American troops remain on the ground in Iraq, more than 1,000 Americans have died, and at least 6,916 have been wounded.

Sources: *NPR News, BBC News and Archives, Center for Cooperative Research, The World,* and *The New York Times*

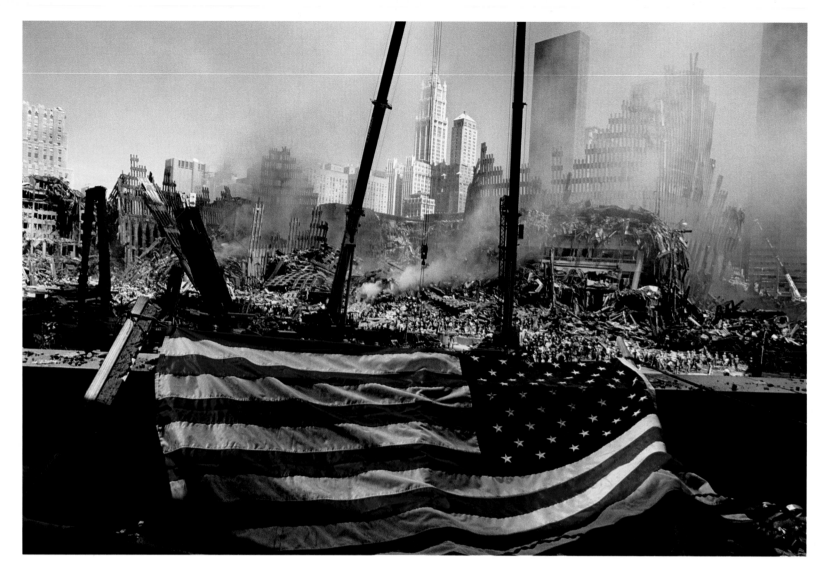

NEW YORK, NEW YORK. SEPTEMBER 14, 2001

ACKNOWLEDGMENTS

My grateful thanks to Nan Richardson and everyone at Umbrage Editions, especially Emily Baker and Andrea Dunlap in design and production, Launa Beuhler in exhibitions, Amy Deneson in publicity, and Whitney Braunstein, Kathleen Conn, Ellen Langer, and Peggy Struck, who worked hard and fast on this project, feeling its political time was now.

Deepest appreciation to Jill Abramson, Cecilia Bohan, Beth Flynn, David Frank, John M. Geddes, Bill Keller, Michelle McNally, Margaret O'Connor, Mike Smith, and all the photo editors I've worked with at *The New York Times*, whose support has been (and continues to be) invaluable.

To my esteemed colleagues: Barry Bearak, Chris Chivers, Dexter Filkins, John Kifner, Neil McFarquhar, David Rohde, and the foreign correspondents I've worked with since 9/11 at *The New York Times*.

A special thanks to John Burns and Ian Fisher for the powerful text for this book.

For their steadfast encouragement, my gratitude to Julie and Darcy Hicks, J. Portis Hicks, and Laura Corwin.

A special thanks to all the translators, fixers, and drivers (too numerous to mention) who make our job possible, notably Abdul Waheed Wafa, Nasir Ahmad Shamal, and in memory of Shihab Ahmed.

For their support of the exhibition and my work in general, thanks to Peter Smith, Boston University; Catherine Johnson, The National Arts Club, New York; Mike Duggal, Duggal Visual Solutions; Kathy Ryan and Kira Pollack, *The New York Times Magazine*; and Susan Kohlmann, Pillsbury Winthrop LLP.

Susan Kohlmann, Pillsbury Winthrop LLP.

To Ranya Kadri in Amman, Jordan.

To the many friends and fellow journalists who have spent time with me in places referenced by this book and beyond, notably Jon Lee Anderson, Lynsey Addario, Chris Anderson, Patrick Andrade, Samantha Appleton, Alexandra Boulat, Alan Chin, Sungsu Cho, Carolyn Cole, Fred Conrad, Adam Davidson, Jerome Delay, Janine DiGiovanni, Thomas Dworzak, Chip East, Gary Fabiano, Tim Fadek, Ashley Gilbertson, David Guttenfelder, Ron Haviv, James Hill, Chris Hondros, Mike Kamber, Gary Knight, Yuri Kozyrev, Teru Kuwayama, Chang Lee, Roger Lemoyne, James Lowney, Alex Majoli, Matthew McAllester, Morgan McClaran, Paul McGough, Yola Monakhov, James Nachtwey, Robert Nickelsburg, Farah Nosh, Heathcliff O'Malley, Jiro Ose, Scott Peterson, Todd Pitman, Spencer Platt, Moises Saman, Joao Silva, Shannon Stapleton, Mario Tama, Andrew Testa, and Ikkla Uimonen.

A special thanks to my fellow photographers at *The New York Times*.

—Tyler Hicks
Baghdad. August 2004

Umbrage Editions would like to gratefully acknowledge the support of the following in this publication and exhibition:

Sidney Kimmel, the M.L. Ward Foundation, *The New York Times*, Michael Duggal, COO of Duggal Visual Solutions, Inc.

And a special thanks to Catherine Johnson, Chair of the Photography Committee at The National Arts Club, for assisting with the launch of the project.

—Nan Richardson, Publisher

HISTORIES ARE MIRRORS TRAVELING EXHIBITION
available through 2008

Exhibition Opening, Book Launch,
and Lecture October 18, 2004
The National Arts Club,
New York, New York

January 19, 2005 — February 21, 2005
Richard F. Brush Art Gallery
St. Lawrence University, Canton, New York

Spring 2005
Boston University Gallery
Boston, Massachusetts

September 26, 2005 — December 10, 2005
Albin O. Kuhn Library Gallery
University of Maryland, Baltimore, Maryland

For more information, please contact:
Launa Beuhler, Director of Exhibitions
launa@umbragebooks.com

T: (212) 965-0197, ext. 1#
F: (212) 965-0276

TRAVELING EXHIBITION:
Total 100 items to occupy 250 linear feet:

- 36 color prints at 20"x24"
- 8 color prints at 30"x40"
- 6 Archival Giclee Photographs on Canvas at 40"x60"
- 3 text panels at 20"x24"
- 50 captions at 4"x6"
- 6-8 week bookings
- Artist is available for panel discussions and lectures

Histories Are Mirrors

Photographs by Tyler Hicks

Essays by John F. Burns and Ian Fisher

An Umbrage Editions Book

First Edition

HC ISBN 1-884167-44-6

Umbrage Editions, Inc.
515 Canal Street
New York, New York 10013
www.umbragebooks.com

Publisher and Editor: Nan Richardson
Director of Marketing: Amy Deneson
Director of Production: Andrea Dunlap
Designer: Emily Baker
Director of Exhibitions: Launa Beuhler
Assistant Editors: Whitney Braunstein, Kathleen Conn,
Lt. Col. Paul A. Deneson, Jr., Jane Kim, Ellen Langer,
Terry Roth, and Peggy Struck

Printed in Italy

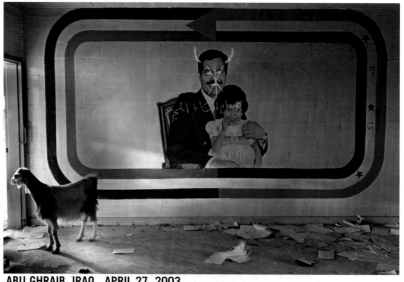

ABU GHRAIB, IRAQ. APRIL 27, 2003
Where thousands of Iraqi prisoners are still detained.